Zeppy

Zeppy, our cover dog, was three when he arrived at the Humane Society of New York (HSNY) with a painful ear infection and a coat so matted it had to be shaved off. Now he runs circles around the Martha's Vineyard acreage of artists and gallery owners Ronni and Peter "as if he's in a three-ring circus." (In fact, the smart and easy-to-train Havanese are often used for circus dogs.) Zeppy goes to work with the couple every day. "We have a steady flow of people coming and going. Zeppy charms them all." Even their son, away at college, schedules FaceTime with Zeppy. A previous dog died eight years ago. "We never thought we'd get another. Now we can't believe we lived without a pet for so long!"

Photographs by Richard **Phibbs**

Text by Richard Jonas

Typography by James Victore

aperture

Richard Phibbs's insightful and arresting portraits of shelter dogs have raised the level of photography to that of art, all to the benefit of the animals for whom he cares so deeply.

For every dog that sleeps in a safe place, there are thousands that do not. In our "throw-away" society, homeless animals have no say in what their lives will be. Frequently, the solution to unwanted dogs and cats is simply to discard them.

Because life has been so unkind to so many of them, it is often difficult to break through their defenses. To discover the spirit of life in a dog that has almost given up trying to find a place of peace takes great skill and patience. Richard manages to capture that spark in each dog by engendering a trust that allows the animal to reveal itself.

In this collection, shelter dogs are seen in a different light. Richard's photographs bring out a touching quality in each that causes people to take a second look at even the most damaged of these creatures. His eloquent and captivating studies have, in effect, changed the face of shelter animals, for which we will be forever grateful.

Virginia Chipurnoi
President of the Humane Society of New York

Taking pictures is my passion. Taking a picture that makes a difference brings me all the more joy and satisfaction.

I've always felt a strong connection with animals. In my travels around the world I've been overwhelmed by the global disgrace of cruelty to animals. Seeing animals in deep distress, I can't just walk by without trying to help.

The cruelty I've seen has left me feeling heavy-hearted and helpless. Volunteering at the Humane Society of New York showed me there are ways we can all help.

The Humane Society of New York is at the very epicenter of an awakening quest to ease the suffering of animals around the world. For four years I've taken portraits of dogs and cats, birds and rabbits at this inspiring no-kill shelter that finds every animal a loving forever home. The dedicated people who work and volunteer here—who truly will do anything to help their fellow creatures, rescuing them from sometimes unimaginable suffering and launching them into new, happy, and secure lives—are a continual inspiration to me.

My portraits of homeless animals are not meant to make people feel sad. The goal is to find every animal a home. I hope to inspire people who are thinking of getting a dog or cat to "adopt instead of buy." By sharing your home and your life with a homeless animal, you become part of this great awakening, this transformation of human consciousness that recognizes the essential value of all living beings.

I believe in the power of photography to speak the truth. When I take these portraits, my intention is to give each animal the dignity that all living beings deserve. These are stories of hope.

Richard Phibbs

Dedicated to all the homeless dogs on this planet who have never had a chance.

trinket

Rescued from a Texas "kill shelter"—which accepts all animals but euthanizes those who don't find a home—Trinket had severe heartworm and weighed only five pounds. It took nine months before she was healthy enough to be adopted. Trinket was "very particular," an HSNY staffer says, "so we promised her she would only go home with someone she picked." Trinket was nervous at first about sharing a bed with Kinsey, Kinsey's husband, and their other Chihuahua, Sweet Pea. "Now I wake up with her sleeping across my face!" Kinsey works for a start-up fashion company, often from her Central Park South apartment, and Trinket "must be in my lap at all times."

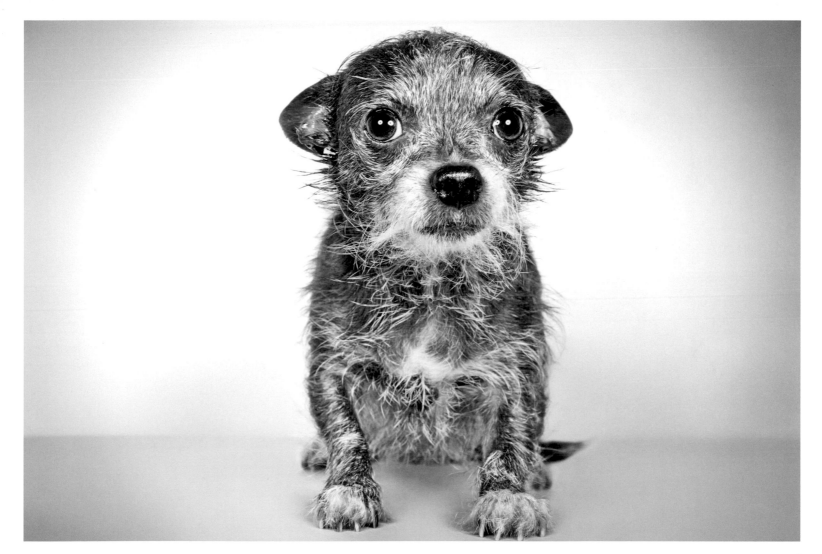

zooey

The person who owned Zooey's mother couldn't cope with the dog's large litter of nine pit bull puppies. An adopter took on Zooey and one of her sisters, but they proved too much to handle. HSNY welcomed both. When Ben got his first look at Zooey, then thirteen months old, "she was so full of life I couldn't stop thinking of her!" Ben and his girlfriend, Jess, are actors and singers—"When we warm up in the apartment, Zooey loves to sing along"—and Jess is in a Broadway show. "If Jess gets a call to go on for one of the leads, she has to drop everything. Luckily a good friend lives next door and loves Zooey!"

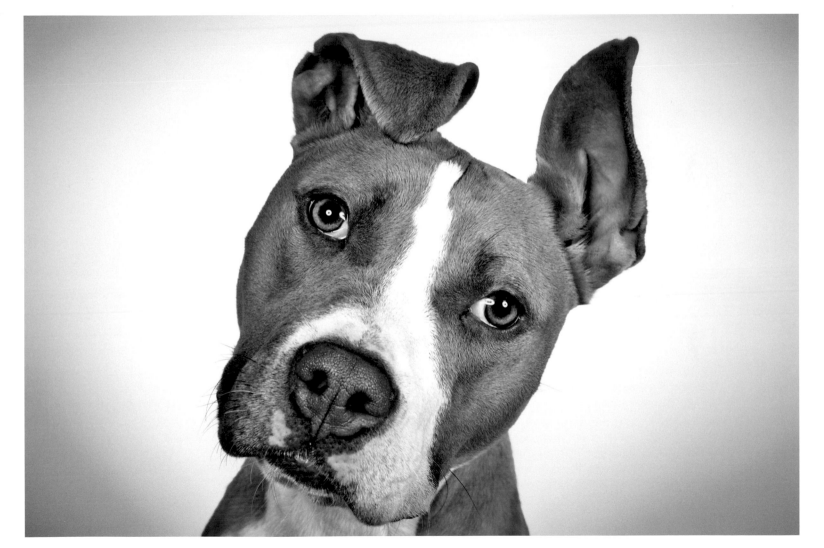

duna

Lana

[opposite] Duna was four when he was abandoned. "Senior dogs," like older orphan children, are often overlooked, but Susan seeks out "hard-to-adopt" dogs. She brought home her first shelter dog ten years ago, and knew right away that Duna belonged with her family—her husband and three sons, that first rescue, and the family's four other dogs—on their two fenced acres in Rockland County, New York. "That face! Those eyes! He was saying, 'Take me home!'" Susan says. "I need to adopt. It makes my heart feel good." She advises new adopters to "give it a chance. It takes a few days for the animal to calm down, to get to know his new surroundings." The reward? "You'll never be loved more!"

[page 14] Lana's owner went to jail. The owner asked her sister to take care of the two-year-old shih tzu, but only after Lana had been left alone for a week. Confined to a small crate, she was drenched in urine, her hair was matted, and she had a painful ear infection. Despite the neglect, Lana was affectionate and friendly—just what Maria was looking for. "My kids have had fish, gerbils, and a hamster, and finally convinced me they were ready for a dog." Maria, a teacher and textile artist, and her husband and daughters, Aiyana and Asha, live in a house with a backyard that Lana loves to zip around. Since Lana joined the family, "we've slowed down in the best way possible."

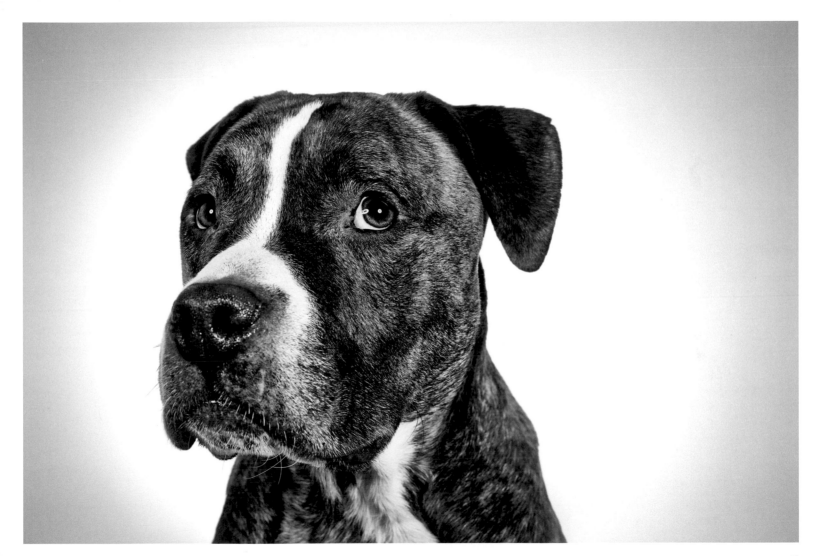

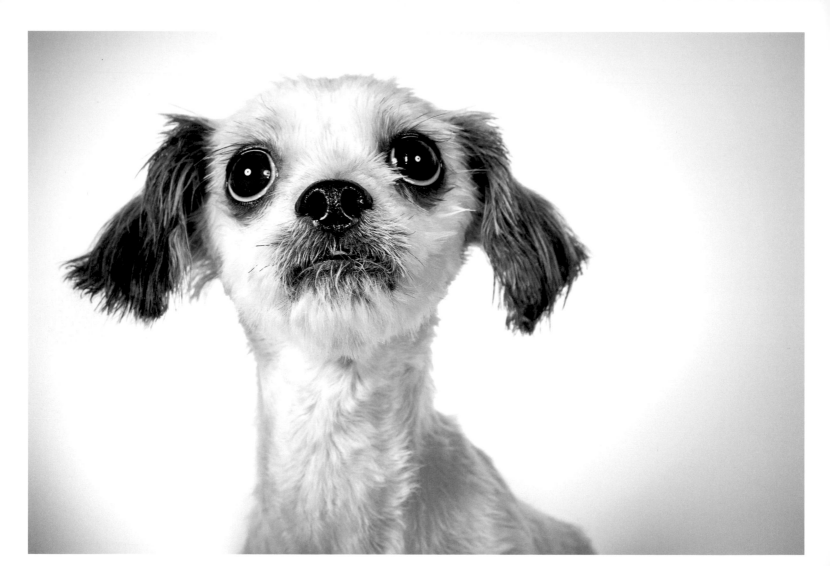

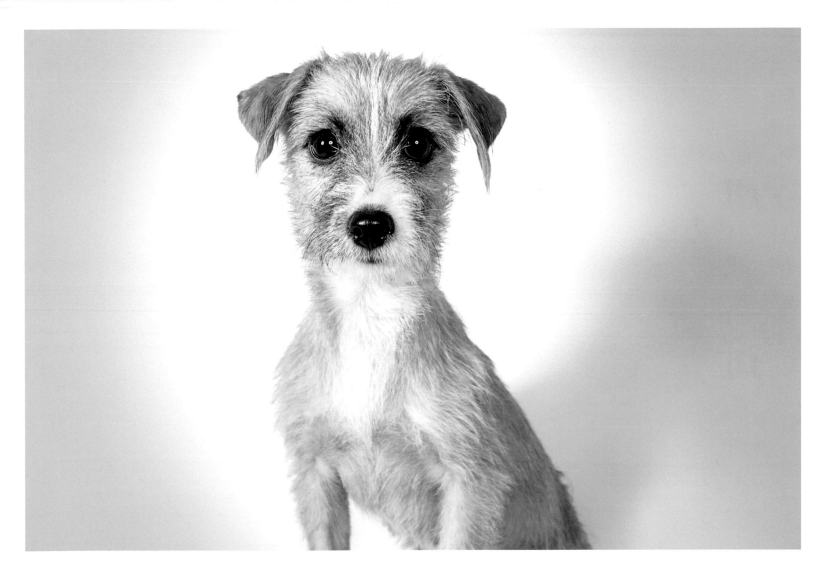

sazeech mo

[page 15] Sazeech was a gift, but his new owner, realizing he didn't have time for a puppy, turned Sazeech over to HSNY when he was only a few months old. Second-time lucky, this poodle-terrier mix found a lasting home with Teresa and Daniel. When the couple moved from their suburban house to a one-bedroom apartment in Manhattan's Inwood neighborhood, Sazeech was "sensitive to the high energy of the city. He heard every noise and felt the rumblings of the subway," which made his ongoing training a little harder. "We progressed more slowly, but we still progressed." Now "there's so much joy in watching this little guy learn to be a dog," Teresa says, "and watching ourselves turn into a family."

[opposite] Time was running out for Mo: a Texas shelter had set the date to put him down. HSNY provided a last-minute reprieve. Diane, a market researcher, and her husband, an attorney, chose Mo based on "demographics," she says, not personality. They'd had "fifty-pounder" dogs before, but with the arrival of a new grandson, there was only enough space in the car for a lap dog when the family traveled from their Upper East Side apartment to their Columbia County, New York, retreat. Sometimes grandson Aaron—"Mo" was his first word—gets too physical, but "Mo puts up with it like a trouper. He has never once growled, though Aaron likes playing with Mo more than Mo likes playing with Aaron."

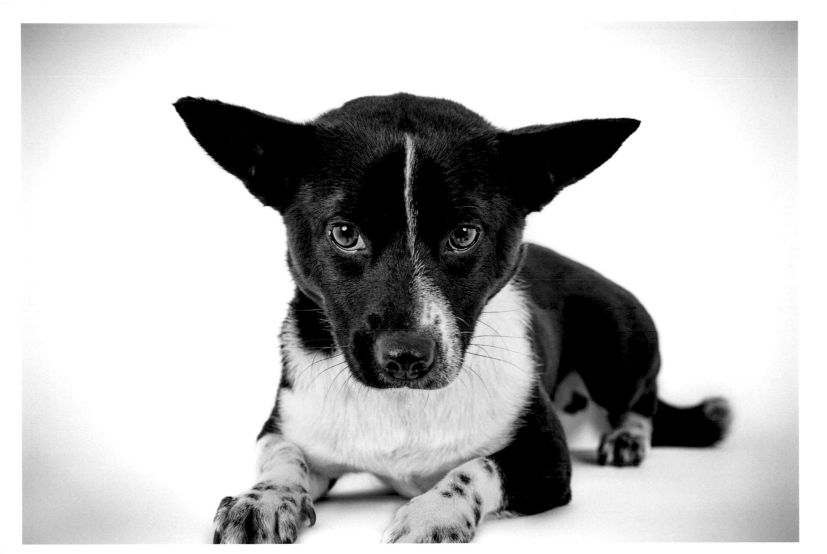

Rebecca Louise

egon

[opposite] Rebecca Louise is waiting for her life to change—again. Originally adopted from a college for veterinary technicians, which keeps dogs for a semester while students learn by nursing them before finding the dogs a home, the female beagle had security until the woman who adopted her became too ill to care for her. The HSNY animal caregivers and kennel manager, all volunteers, are charmed by Rebecca Louise's kind, friendly manner. They noticed that she was drinking lots of water and frequently urinating; testing showed she has diabetes insipidus. With daily eye drops, the illness is under control and the five-year-old is healthy and ready for her second adoption and another new start. Now it's your move.

[page 20] Committed to a Texas kill shelter as a stray, this Chihuahua mix arrived at HSNY at nine months. At first he had trouble adjusting to big-city life, but "he's a New Yorker now," says Mary, who, with Evan, adopted him. During a blizzard, Egon, who had never seen snow, balked at taking his walk. By the next day, he was climbing snow banks. Egon goes into "hyper mode" at the dog run and loves being chased. In bad weather the couple tosses toys as he streaks up and down the long hallways of their apartment. "It took time and patience for Egon to develop trust," Mary says. Now he relishes "a good ear scratch and belly rub" from neighbors he encounters on his walks.

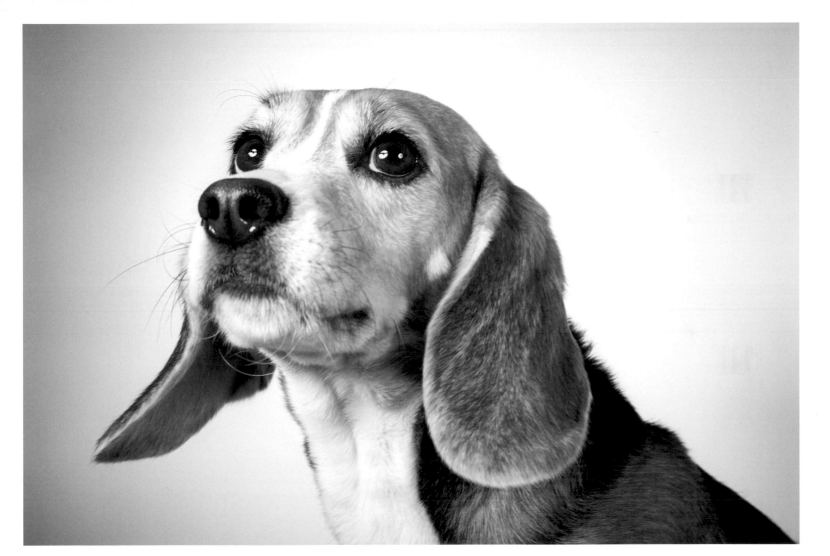

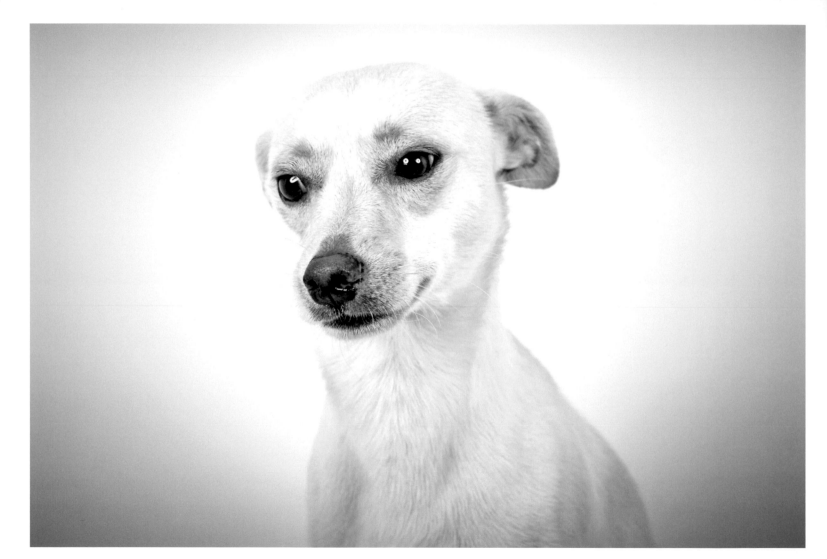

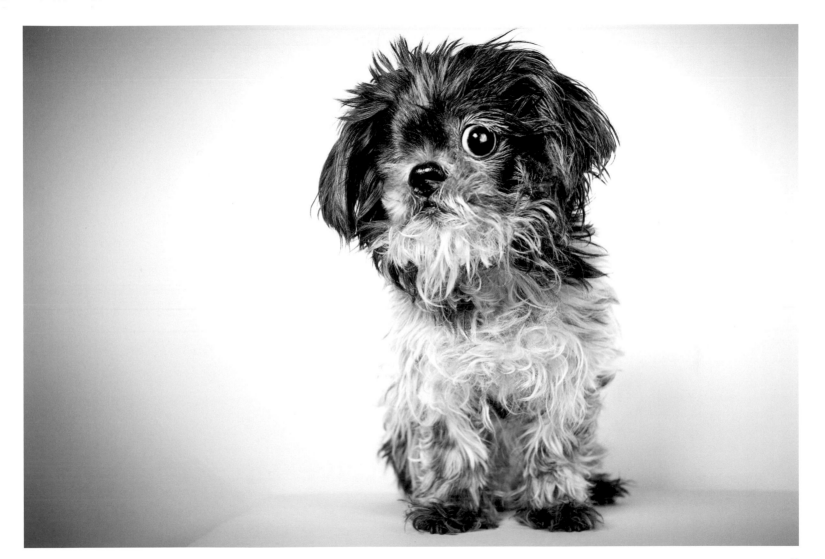

Buddy

leo

[page 21] Nearly fourteen when his owner surrendered him, Buddy hadn't been to a veterinarian in years and had chronic ear and skin infections, a severely matted coat, and an eye so damaged it couldn't be saved. HSNY thought Buddy would fare best in a one-dog home, but decided that Melissa, who had experience with "senior dogs," was perfect for him. Buddy "nicely balances the household," which also includes Paris, another rescue, Melissa says. Paris is nervous and restless, "but Buddy is very chill, so it works." The three cross the street to roam around Riverside Park. "I have no qualms about spoiling Buddy in his golden years. I adore them both so much, I think my heart might explode."

[opposite] Leo was a nearly eight months old when a family surrendered him to HSNY because he was "too strong." But training the "super-smart" chocolate Labrador, now almost two, came easily to Dan and his partner, Esteban, who live near dog-friendly Washington Square Park. Now Leo tries to catch the water as it rushes out of a hose and rests his head on the back of Dan's neck on the drive home from beach weekends. "I have a stressful job," Dan says, "but Leo greets me at the door and changes my mood as soon as I get home. When you're busy, it's easy to forget to care and share," he continues. But Leo keeps reminding them.

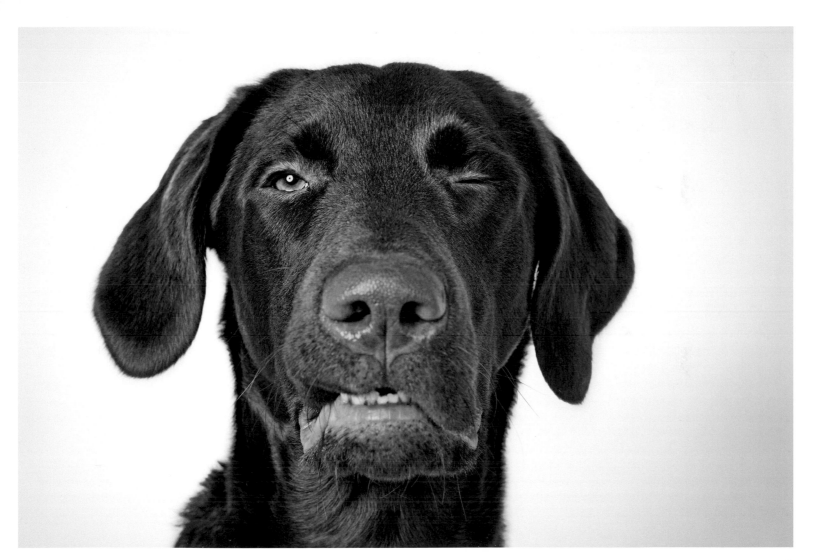

HERSchel

Bill

[opposite] A policeman found Herschel abandoned on the street. Chessa came to the Humane Society to adopt a Jack Russell pictured on its website, but knowing she wanted a dog who could fly in-cabin with her, the staff suggested two-year-old Herschel instead (the Jack Russell was prone to motion sickness). Chessa "schleps Herschel everywhere. Toting twenty-five pounds while you race up and down the subway stairs is a real workout!" Previously mistreated and abandoned, the terrier mix had "severe separation anxiety" at first. "We couldn't leave him on-leash for two minutes while grabbing a coffee to go. Over time, he's come to trust that we will always come back. Love and stability are the cure for a past life of cruelty."

[page 26] No one intended to leave Bill homeless or force him to go years without medical care. The English bulldog was two when he was given to a family. They treasured him for three years until they had to move and couldn't take a dog along. They placed Bill with the family's grandparents, but the grandfather was too ill to walk Bill properly and Bill was too strong for the grandmother. The couple couldn't afford to take Bill to the veterinarian. When he arrived at the Humane Society of New York, Bill had heartworm disease and needed five months of treatment and rest. Now cured, Bill has a friendly, funny disposition. He's patiently waiting to go home.

Kirby

ariel & lily

[page 27] Kirby was left at HSNY by a man who said his family was moving and couldn't take the five-year-old dachshund/Chihuahua mix along. Shy at first, Kirby is still quiet. Staffers remember him lying contentedly on his bed, playing with his toys, while other dogs barked. "I felt a void as I turned thirty," says first-time dog owner Daphne, a creative services coordinator. That was then; this is now. Kirby is "my companion, my best friend. I didn't realize how lonely I was until he came into my life." The two share a Brooklyn apartment—a section of the living room is devoted to the dog Daphne calls "King Kirby"— and jog three times a week in dog-friendly Prospect Park.

[opposite] Ariel (left) and Lily (right) arrived at HSNY at eight weeks old. Ariel found a home with Emily's family. When acting in the Broadway revival of *Annie*, Emily worked with several dogs who played Sandy, all trained by Bill Berloni, HSNY director of animal behavior and training. "Bill taught us the importance of adoption," says Emily's mother, Rachel. "The staff made us confident that Ariel was the right match." Lily was found by Thomas at Broadway Barks, an adoption event in Shubert Alley. "This bundle jumped from someone else's arms into mine." When Thomas's mother underwent a knee replacement, "Lily had as much to do with her healing as the doctors. When she walked without a walker for the first time, she started crying. Lily licked her tears away, like a Hallmark movie."

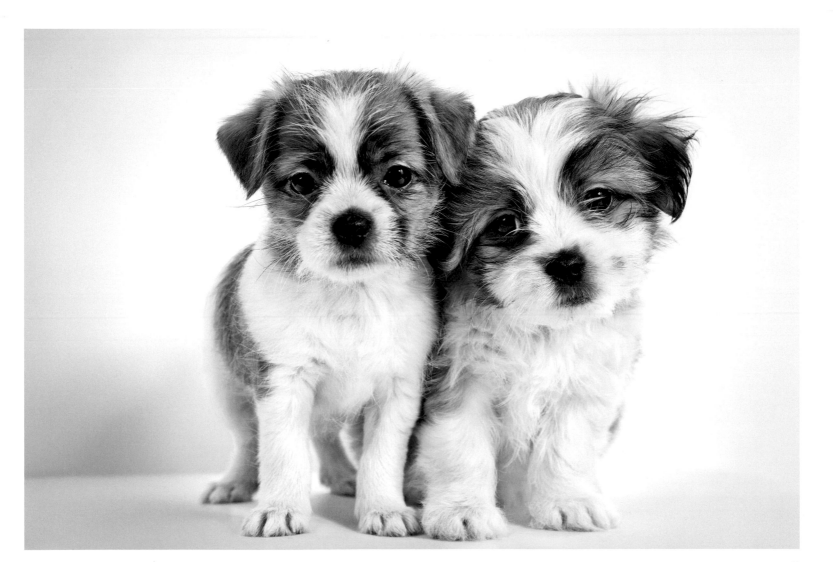

Boshka

Boshka was five and knew his commands—in Russian—when he was brought to HSNY by a family that was moving and couldn't take him along. Staff taught him the English equivalents and looked for a home where the boxer would have a regular routine and space to run. Patricia's ménage includes a rescued cow, goats (Boshka grooms the kids), a horse, three donkeys, four dogs, and three cats, all sharing a 250-year-old house in central New York State. At first, it was a challenge for the retired flight attendant to integrate dominant Boshka into the pack, "but he has settled in with the female dogs," says Patricia, who calls Boshka "Mr. Handsome."

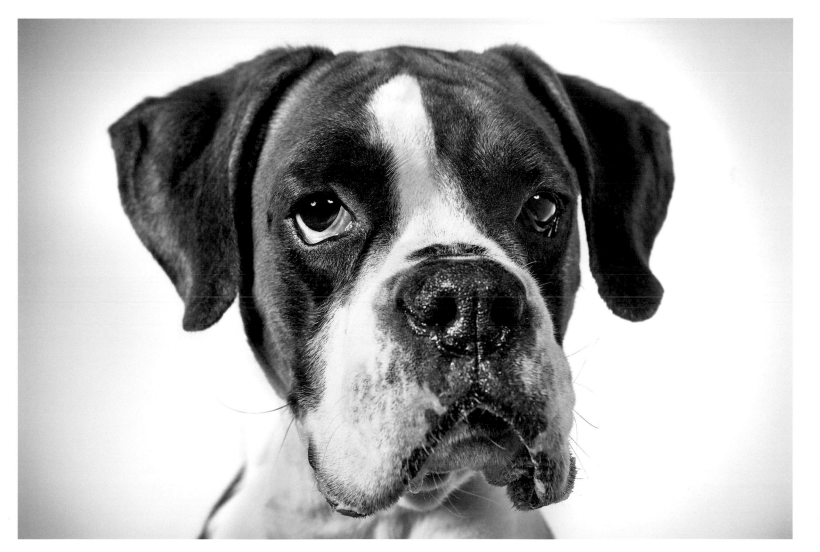

little Lowell

Police found Little Lowell locked in a portable kennel on a punishingly hot day in May. Filthy, urine-soaked, and terribly dehydrated, he had apparently been imprisoned for some time. Under his matted coat he was skin and bones. One damaged eye had to be removed—but now things are looking up for Little Lowell. Julia and Bruce kept his original name to honor the HSNY adoption animal caregiver who stayed by six-year-old Lowell's side throughout his recovery from surgery and the severe fungal infection that followed. "The name reminds us of the work the Humane Society of New York does," Julia says. "Big Lowell" Santiago sometimes visits his namesake at the couple's townhouse off Fifth Avenue in the Village.

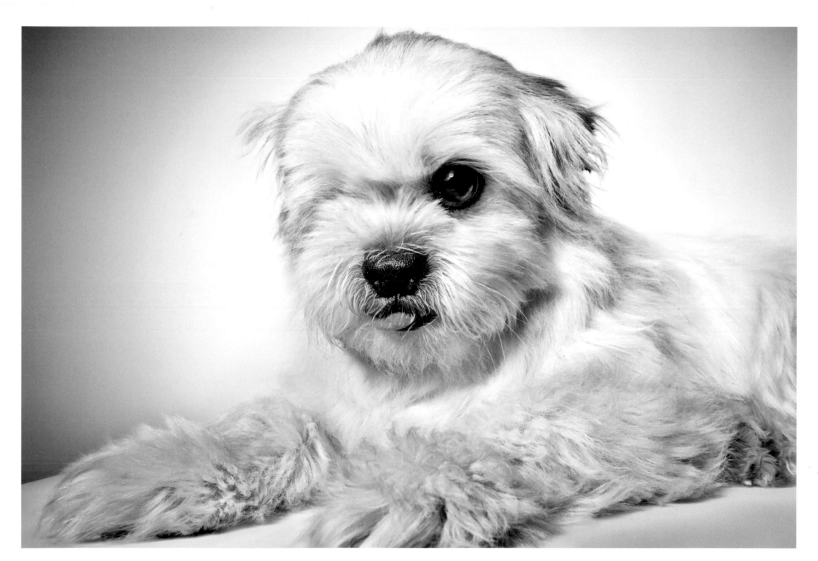

Harry

Harry, fourteen, was found aimlessly walking in Queens, apparently abandoned. HSNY helped his weak knees with regular injections and laser treatments. Mark, a tree surgeon, saw the corgi/pug mix on a morning TV show and "we had to adopt him," says Cathy, a teacher. Their suburban backyard gives arthritic Harry all the exercise he needs; though he's deaf, he manages to "hear" the can opener at feeding time. Harry gets on well with the couple's other "senior dog," Brodie; their sixteen-year-old African gray parrot has welcomed Harry "as one of his flock." The changes in Harry's life show in his face, Cathy says. "The photo shows a sad, pensive dog. Now I see a happy little guy."

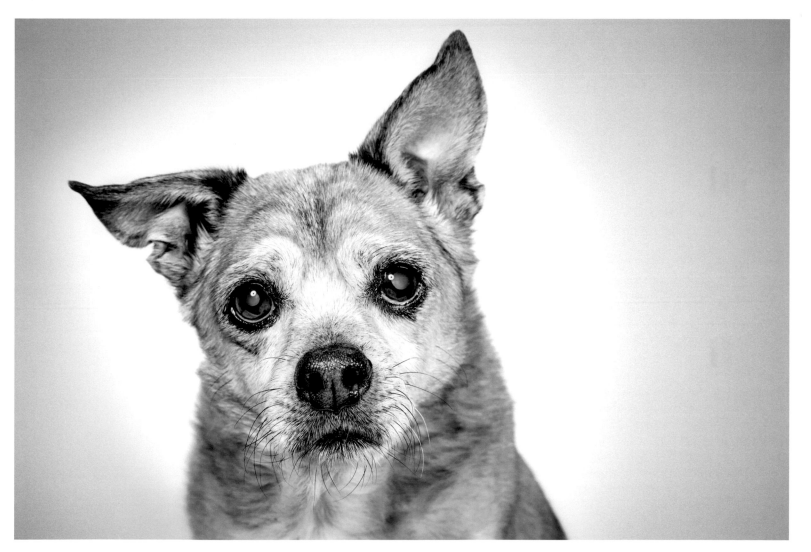

CAPTAIN Cuddles

Captain Cuddles, two siblings, and their mother were given to a woman who soon realized she could only handle one puppy. A neighbor kept the mother; the two other puppies ended up at HSNY. The French bulldog, just seven weeks old, was adopted by Jeremy (he manages a restaurant) and Ashley (she works in human resources). The two hadn't planned on adopting a puppy, but now they revel in Captain Cuddles's "natural curiosity about all the new things around the house, which made them new for us too," and in the way he helped their other rescue, a Chihuahua named Major, "come out of his shell and learn to be a dog." The four share an apartment in Washington Heights.

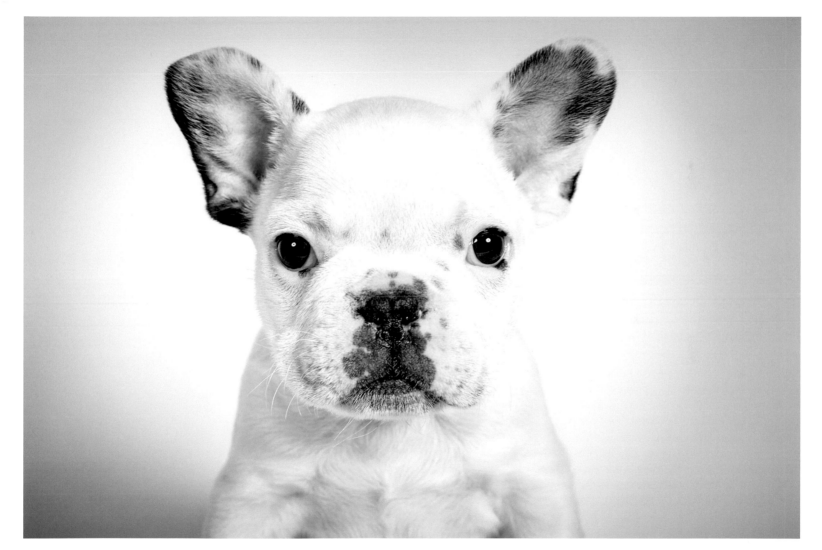

Finn

A former owner bought Finn, then decided he couldn't keep him—all before the long-haired Chihuahua was two months old. Richard Phibbs knew what he didn't want in a dog—he did not want a purebred, a toy, or a fashion accessory. Then came Finn. "When I put him on the platform to be photographed," remembers Richard, the photographer and author of this book, "it was an instant connection." Having lost a much-loved dog a year before, Richard wondered if he was ready to adopt, but he couldn't stop thinking about Finn, affectionate and spunky with an outsize personality. "I realized I was discriminating because he was purebred and small." The two have been together ever since.

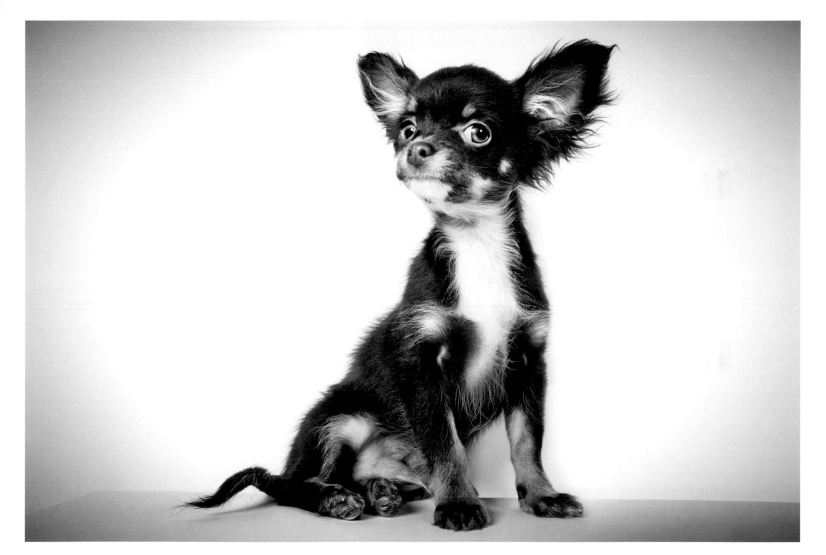

nuno

When Nuno's first owner left him with her mother, things got even worse for the bichon frise, who was kept tied to a doorknob and fed but not walked or groomed. A neighbor called HSNY, which persuaded the mother to surrender Nuno. Now ten, Nuno found his happily-ever-after ending on the Upper West Side with Lorea and Dan and daughters Ana and Julia (during Julia's singing lessons, Nuno puts paws to keyboard and begins to "yap as if he were singing too"). Taking Nuno to Riverside Park, "I'm outdoors several times a day and feel more connected to the park and our neighborhood," Lorea says. "It wasn't until we got Nuno that I felt like a real New Yorker."

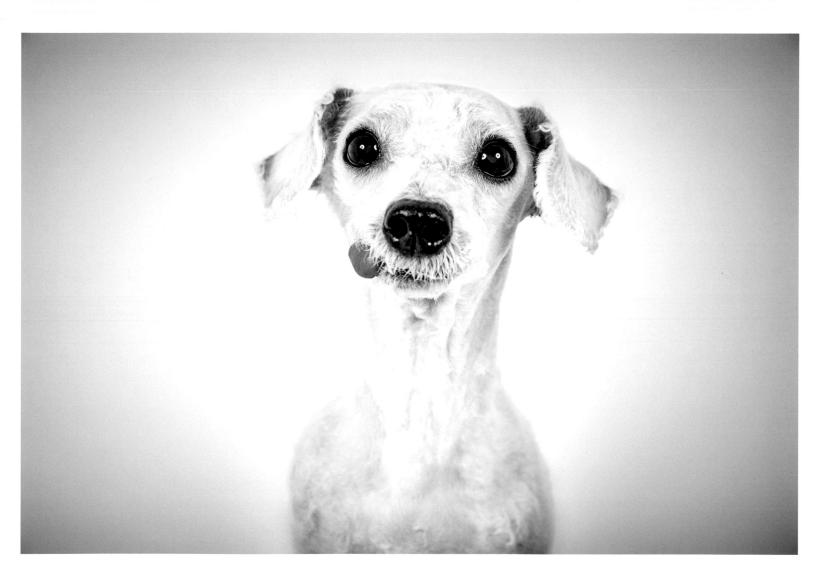

davey　　Luce

[opposite] Found running in the Bronx with no collar and no leash, Davey's been in motion ever since. "Nothing wears him out," says co-owner Chris, a foundation director who lives in West Chelsea. "He's a ball of energy at the dog run—he's an acrobat, he ducks and dives, he runs between dogs' legs and jumps over them." But Davey is "a homebody too," Chris says. "He likes adventures, but likes to have them in your presence." Chris and his partner, Tony, chose Davey from his photo, smitten by his mischievous sidewise glance. They kept the name chosen by HSNY, in honor of the husband of the New York City policewoman who found Davey.

[page 44] Luce found and lost several homes before she was third-time lucky. Puppyish and energetic, she was too much for her original owner. An animal lover in failing health rescued her, but HSNY promised him they'd find her another home if Luce became too much for him. Finally Kyle met Luce, then four or so. "She had a sweet way of wrapping herself around people," Kyle remembers. After a year of sharing Kyle's Upper East Side apartment, Luce knows all the basic commands and loves snow, though "sometimes she can't tell the depth. She jumps in and disappears!" Along with prompting "friendly conversations with neighbors," Luce's arrival has made another difference in Kyle's life: "having a friend around all the time."

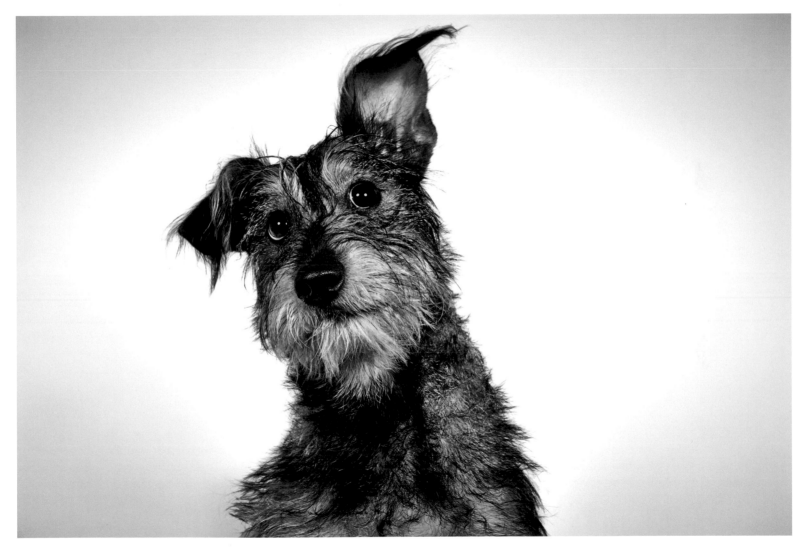

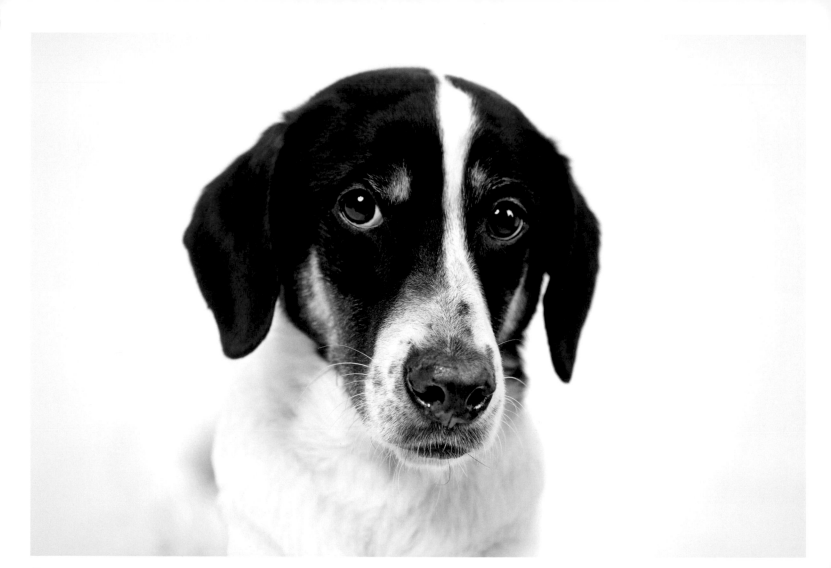

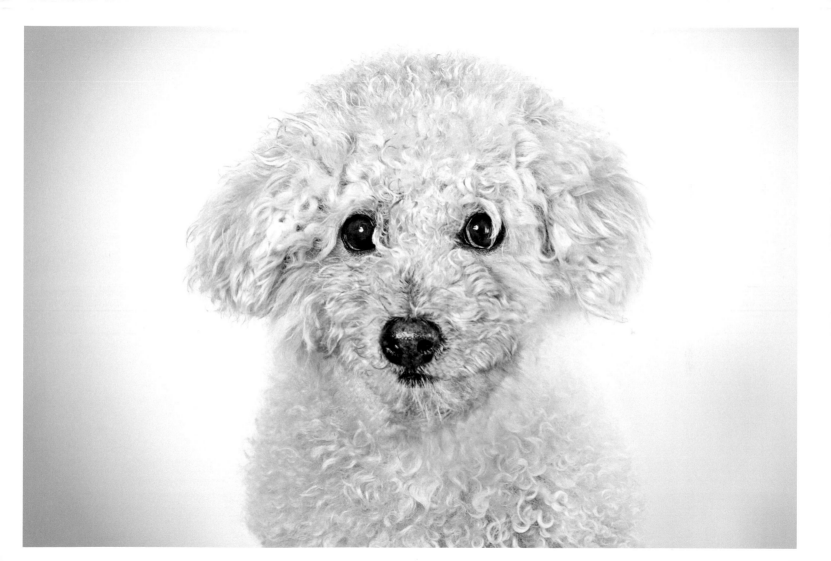

gerard

Pampa

[page 45] Gerard was ten when he came to the Humane Society of New York, surrendered along with two adult Chihuahuas and two puppies. All have found homes except Gerard. The bichon frise is playful, loving, and curious, but hesitant at first with people he doesn't know and uncomfortable in noisy, busy places. Once HSNY started him on antianxiety medication, Gerard was transformed. Now he's carefree and relaxed, and he gets along well with other dogs. HSNY is looking for a quiet home for Gerard, and an owner who will keep him on his medication.

[opposite] Pampa lost his home the way many dogs do—his owner got sick and couldn't care for him. Now he lives with Leslie and her other Yorkie, Paco, on the Upper East Side, just a block from HSNY, where Leslie adopted him. When she and Pampa walk by they stop in "and Pampa is always happy to say hi to his old friends." Pampa sleeps in Leslie's arms like a baby. Awake, though, he can be a little mischievous and chew her reading glasses. Growing up in Argentina—Pampa is named for the Argentine Pampas—Leslie brought home many strays. An anesthesiologist, she sees "very sick people, but thinking of my dogs always puts a smile on my face."

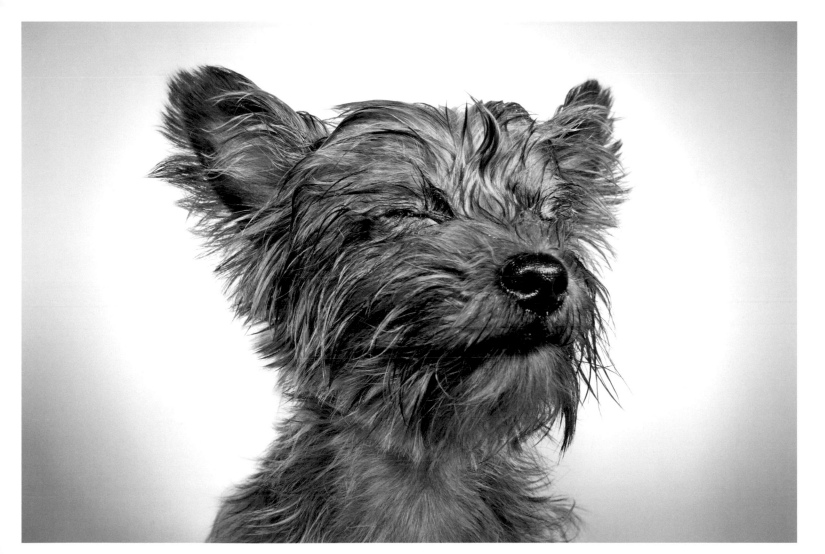

Buster

Isabella

[opposite] An NYPD patrol found Buster abandoned on a Manhattan street, scared and dirty. All-over bruises and lacerations were too-apparent signs of the abuse he'd endured. It took weeks of tender loving care before Lowell Santiago, the HSNY adoption animal caregiver, could gain Buster's trust, heal his wounds, and build up his strength. Unfortunately the injury to his eye was so severe that it had to be removed. "This doesn't feel like a shelter," visitors to the Humane Society of New York's Fifty-Ninth Street headquarters often say. "It feels like a home." But this two-and-a-half-year-old Chihuahua, now healthy and ready to move on with his life, is still waiting for his own home.

[page 50] Isabella, then five, was surrendered to HSNY by someone who had too many dogs. A "huge dog lover," Liz Rosenberg had lost two dogs and both her parents in a single year. "There was a terrible hole in my heart." Enter Isabella. "Nothing Izzy does isn't cute," Liz says. "She has a PhD in cuteness." An entertainment publicist who worked with Madonna and now represents Cher, Stevie Nicks, and Michael Bublé, Liz shares care of Izzy—formally Isabella Mon Amour, after the Charles Aznavour song—with Phil. Both "spoil" Izzy and another rescue, Tootsie. "It's their house. We just live in it." In her picture, "Izzy's eyes are hopeful she'll find a loving home," Liz says, "and she has."

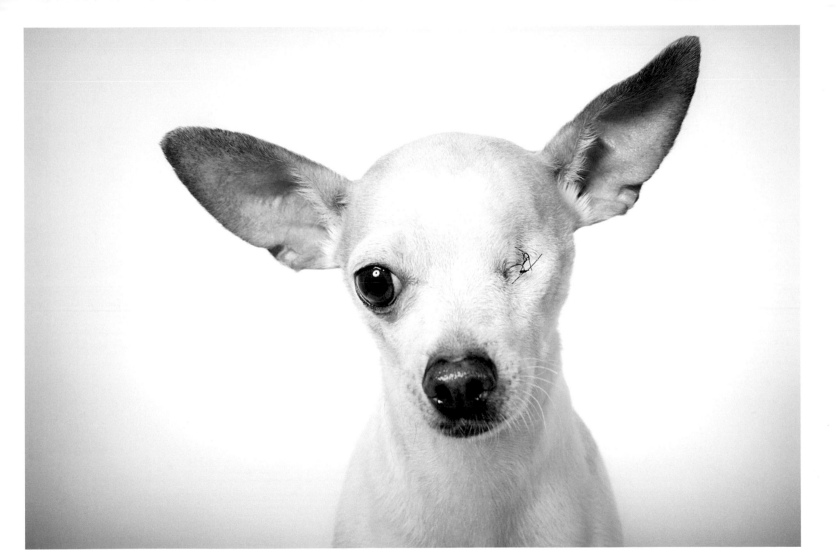

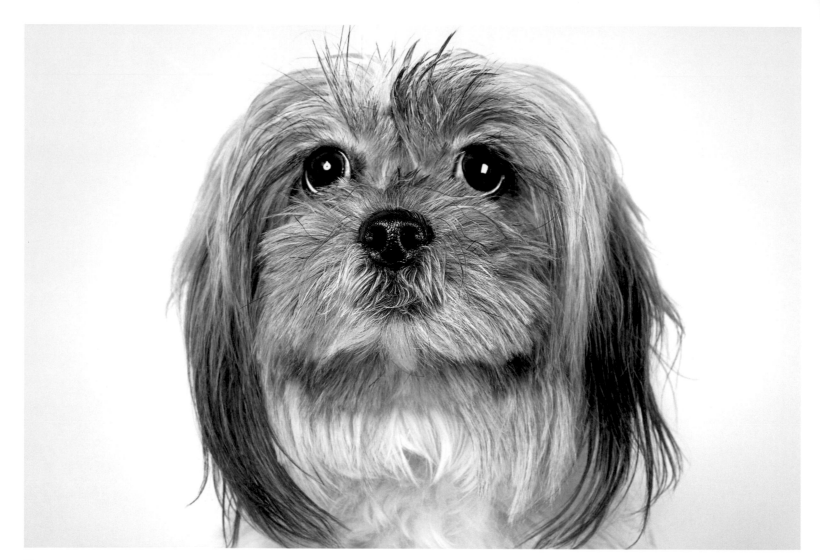

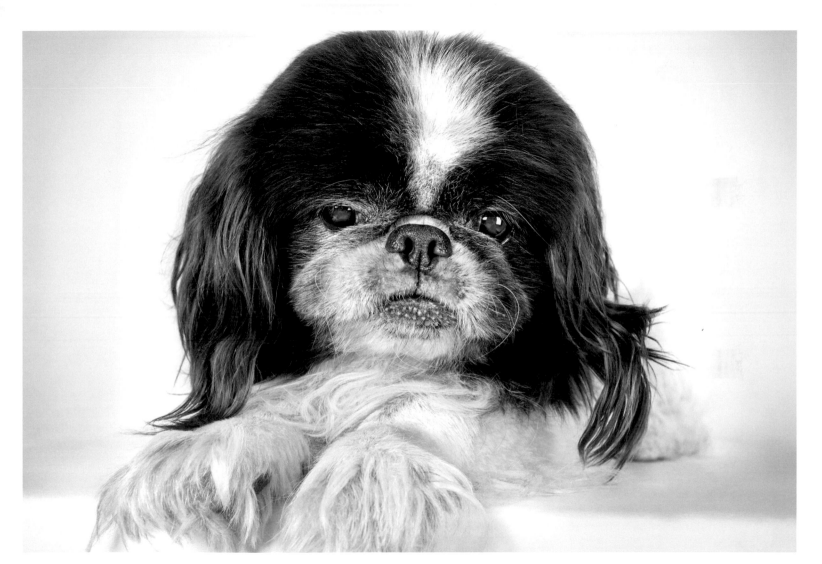

[page 51] Roscoe was abandoned and tied to a "No Parking" sign on a Manhattan street, with no collar and arthritis so severe he couldn't stand for more than a few minutes. A woman wrapped him in a blanket and brought him to HSNY. After months of joint supplements, laser treatments, acupuncture, and sleeping on an orthopedic bed, Maurice and his considerable charm earned him a comfortable berth with Cathleen, her husband, and their three other dogs. "When I asked Roscoe if he'd like to move to Atlanta and eat fried chicken, he barked more than enthusiastically," remembers Cathleen. "He had the biggest smile on his face while flying down—he earned his Delta wings and wooed every steward on board."

[opposite] Luna was surrendered to HSNY at eight months by a family that couldn't give her the space or time she needed as she grew. The Labrador/Weimaraner mix with the chocolate coat was first adopted by a New Hampshire family with a second dog. HSNY emphasized that if the dogs didn't get along the family could bring Luna back. "Our motto is, 'If it's not your animal, it's our animal,'" a staffer says. Eventually Luna was returned. Her luck changed when she met Brian and Hilary. "We knew from our first visit that Luna had a home with us forever," Brian says. The couple lives in Chelsea and makes sure natural athlete Luna gets three to five daily walks.

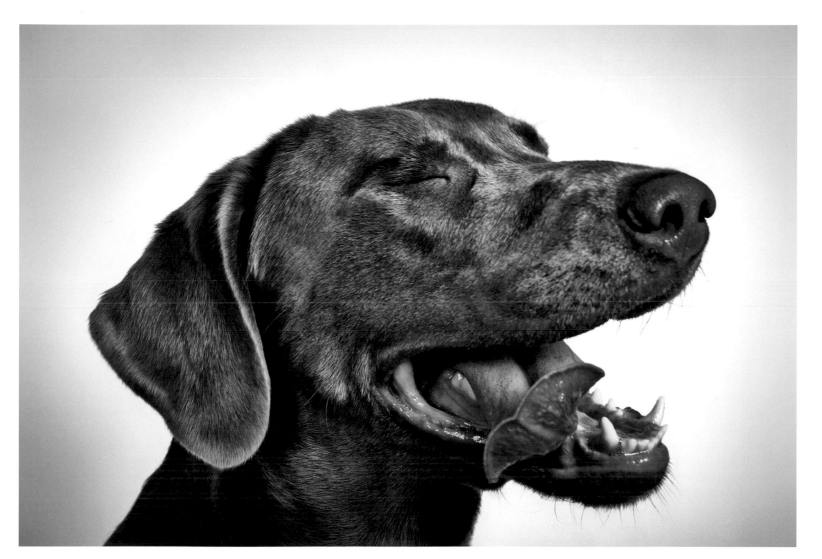

Odin cookie

[opposite] Odin lost his home unexpectedly. He was living with a financially strapped family that was forced to move in with another family, whose members were allergic to dogs. For months the first family searched for a no-kill shelter that would promise not to put Odin down before he could be adopted. Another organization pointed them to the Humane Society of New York, which immediately accepted the twelve-year-old beagle mix, guaranteeing to house him for as long as needed. Odin needed emergency surgery to remove bladder stones that had nearly blocked his urethra. Now recovered, Odin is very social. He loves to meet people and go for walks. "A friendlier fellow you will never find!" says an HSNY caregiver.

[page 56] Cookie and her brother Taco were delicate pups born with open fontanels, a soft, unprotected spot at the top of the head. Dogs like this need special care to avoid serious brain damage. Christine, a licensed veterinary technician, knew just how to safeguard them. Surrendered to HSNY along with their parents by an owner who couldn't manage four dogs, Cookie and Taco were only twelve weeks old when they met Christine. "They were so adorable but so afraid," Christine remembers. "As I held them in my lap, they calmed down and cuddled close. I had to honor their trust in me." The three share a suburban New York apartment.

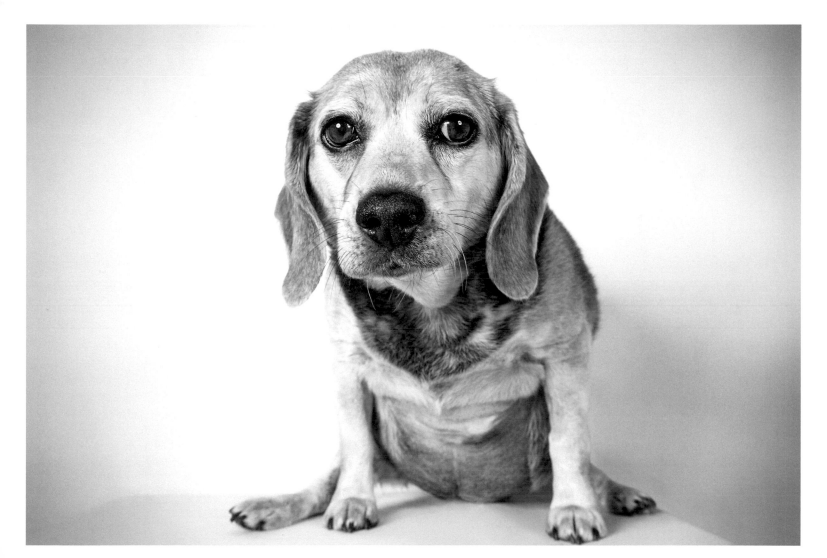

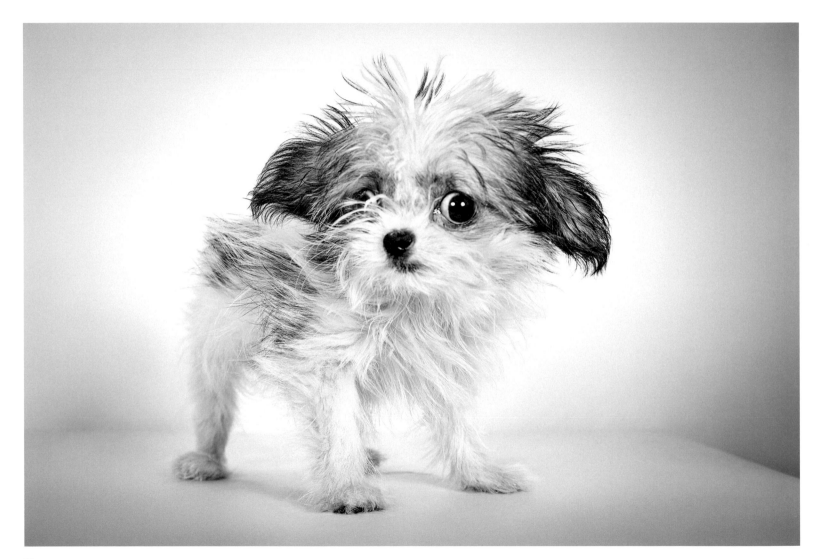

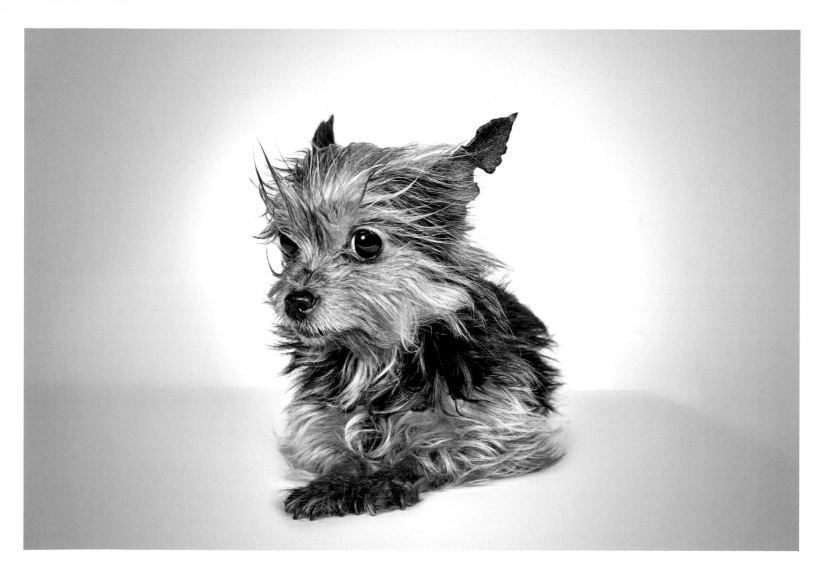

Princess Fiona Mae

Moose

[page 57] The fragile shih tzu was five years old but weighed just two-and-a-half pounds. Her allergic owner had kept her isolated in a separate room before realizing she should live with people who could spend time with her. Now fattened up to three pounds, the renamed Princess Fiona Mae ("She deserved a beautiful princess name," says rescuer Ashley) has a royal lifestyle that includes four beds, a basketful of designer toys, a suede-and-Swarovski-crystal harness, a nanny, and five thousand Instagram followers. Ashley, a hair colorist at a popular salon where Fiona Mae is the "unofficial mascot," takes her teacup princess for three walks a day, but "in winter we do our walks inside stores. Her favorite is Bloomingdale's."

[opposite] Threatened with eviction and too sick to care for a dog, Moose's former owner turned him over to a cat rescue organization, which in turn asked HSNY to help. A Portuguese podengo mix of the *pequeno* (small) variety, Moose, now two, has the breed's double coat—soft underneath, wiry on top—and loves to romp, run, and chase. These days, home is a spacious apartment in a pet-friendly Manhattan building that he shares with Sharda, a jewelry designer, and Lawrence, a consultant. Moose howls along with fire-engine sirens and dances on his back legs, waving his two front paws. But his greatest trick is "completely transforming our lives. Our son, Spenser, has a much-longed-for pet/best friend."

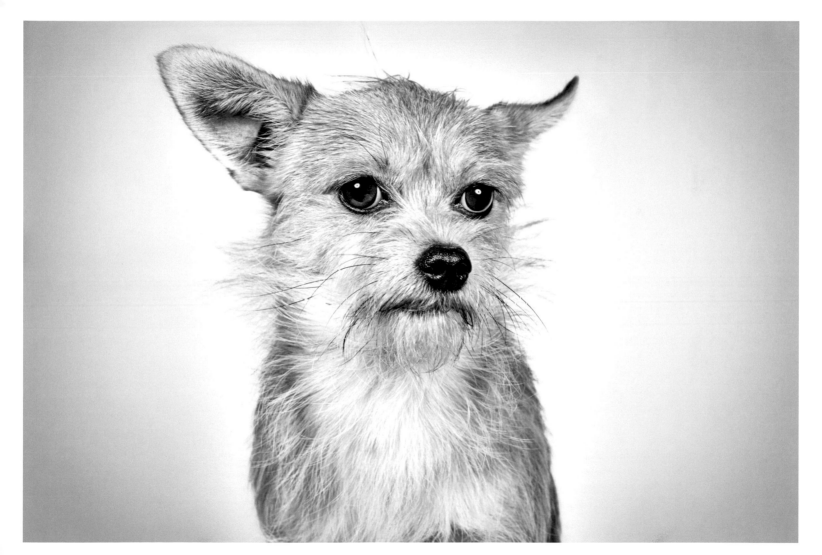

ava

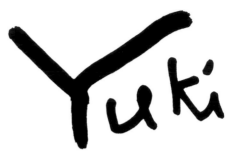

Yuki

[opposite] At four months old, Ava lost her first home. An over-scheduled New Yorker who hadn't realized a puppy would need so much time and attention surrendered Ava. Two months later, Anita brought Ava home for her daughter Isabelle's thirteenth birthday. HSNY discourages giving animals as presents in case the recipient isn't prepared for the responsibility, but Isabelle is a junior volunteer who plays with the dogs and cats at HSNY. Now the three live a few blocks from HSNY on New York's Upper East Side. Anita is an artist; Ava sits in her lap while Anita paints. Isabelle says, "Ava crawls into my sweatshirt when I do my reading. She's like a sibling—funny, annoying, and like my furry BFF."

[page 62] Forced to compete for attention in a house shared with too many other dogs, sweet, delicate Yuki couldn't get the care she needed. Almost five months old, she was shy and in need of medical attention when she arrived at HSNY, but in time the Chihuahua grew confident and trusting. Giancarlo, a hair colorist, chose her new name, which means "snow" in Japanese. The two share an apartment in Chinatown and Yuki gets two walks a day around the bustling neighborhood. Like many other adopters, Giancarlo says "taking care of someone other than myself" filled a place in his life. "I've become more responsible. I couldn't imagine my life without her."

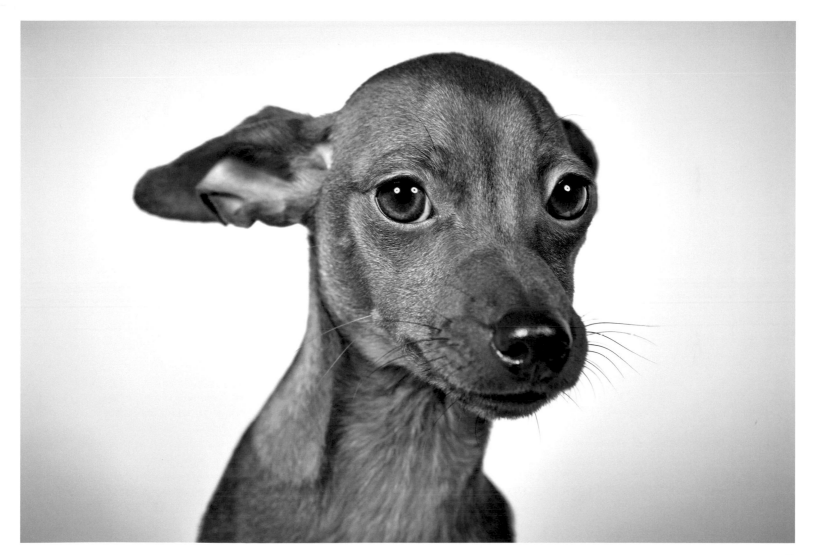

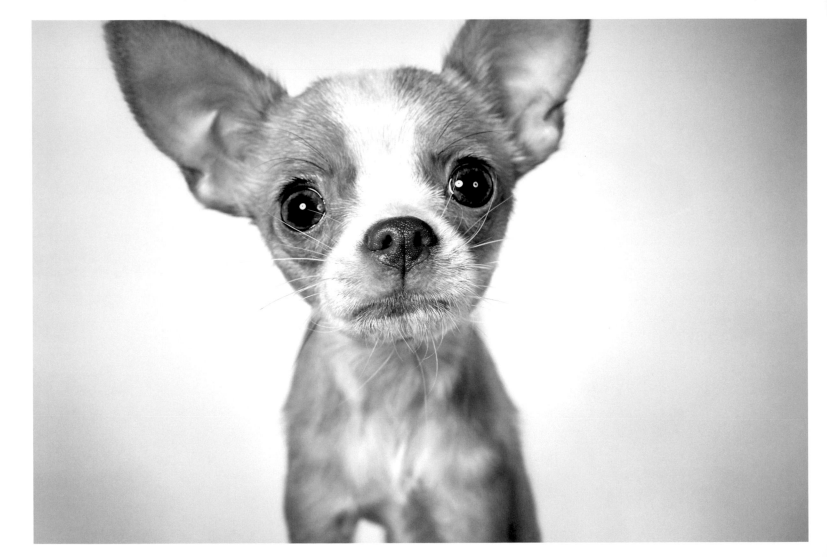

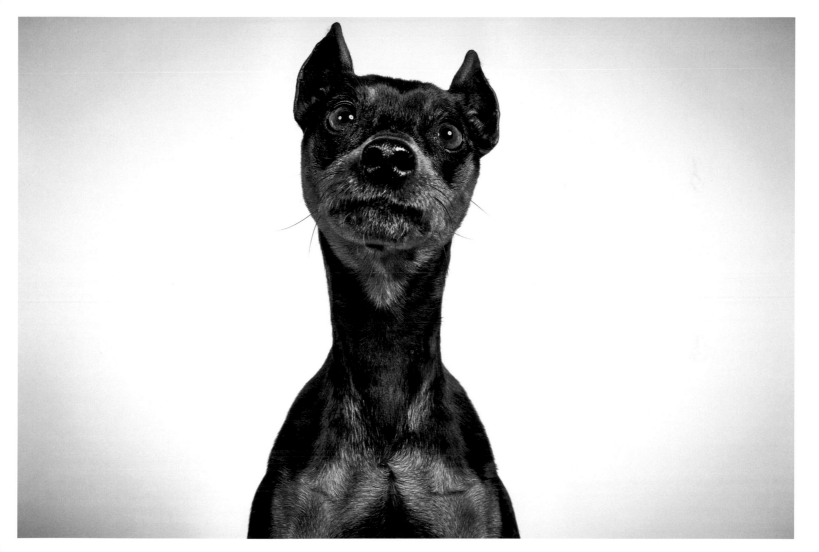

nino

willis

[page 63] A woman found five-year-old Nino wandering the streets. Sure someone would come looking for him, she took him home, fed him, and bathed him. Sadly, no one came. She couldn't keep Nino because she already had a dog, so she turned him over to HSNY. Victoria and her husband brought Sasha, their three-year-old miniature Doberman pinscher, to their first meeting with Nino. "We wanted a companion for her," Victoria says. Nino fell for Sasha right away, though the two later went through some sibling jealousy. Now they're fast friends again: "Sasha is glued to Nino's side." Victoria's kindergarten class loves to hear stories about Nino and, she says, "It's as if he's been part of our family forever."

[opposite] Willis was only six months old when he was found, tired and hungry, wandering on Staten Island. As with many rescues, his backstory is a mystery—but to the Humane Society of New York, he's "a gift from heaven," says Sandra DeFeo, executive director. Willis is the "author" of the HSNY blog, which encourages adoption and shares veterinarians' advice on pet care and news about animal welfare. Willis describes himself as "a little eccentric" in the HSNY blog and proves it by living happily alongside five best-friend cats. "He's happy to 'sing' for us and makes everyone who comes in smile. There's no one like Willis. When people ask what breed he is, we say 'one of a kind!'"

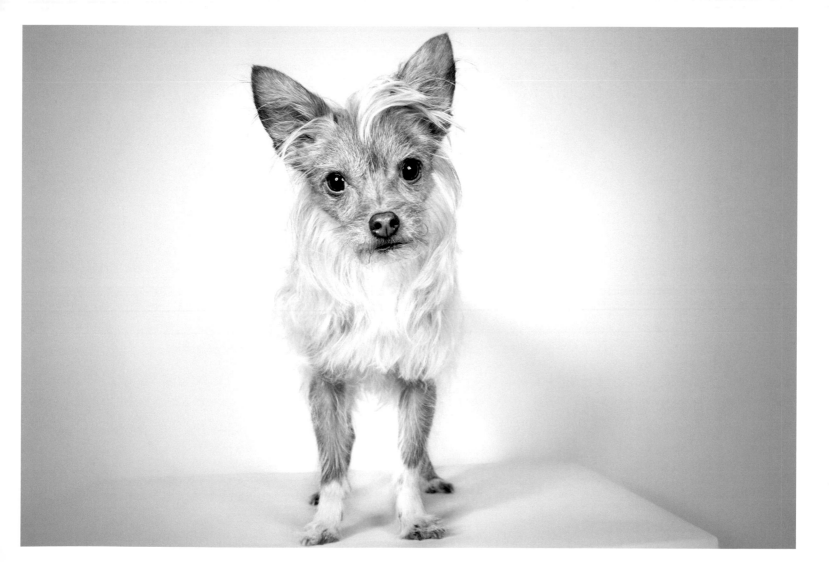

dougie

violetta

[opposite] Dougie's hard-pressed owner—caring for a new baby and moving into a city homeless shelter—sought help with this Jack Russell mix and his sister for months; finally she called HSNY. Nan and her husband, both retired, say Dougie easily adapted to the elevator ride to their eighteenth-floor apartment overlooking Astoria Park. Winning over the neighbors—including the group of elderly residents that waits in the lobby each afternoon for a daily petting session with Dougie—came just as naturally. "The wonderful thing about a rescue is watching its character emerge," Nan says. "Every day you find something new," like the way Dougie "attacks the vacuum cleaner whenever I use it."

[page 68] A rescuer found Violetta living with too many other puppies in too-crowded quarters, neglected and uncared-for. The rescuer managed to free them but could not keep them all herself, and she asked the Humane Society of New York to help. HSNY's program for new arrivals includes complete medical and behavioral evaluation and spaying/neutering, vaccinations, and deworming. A microchip is injected between the shoulder blades as a permanent pet ID. Having received the HSNY treatment, this Westie/poodle mix, not quite a year old, is ready for adoption. Smart, sweet, and lots of fun to play with, she's "a puppy all the way!" staff members say. Now Violetta waits for one more rescue.

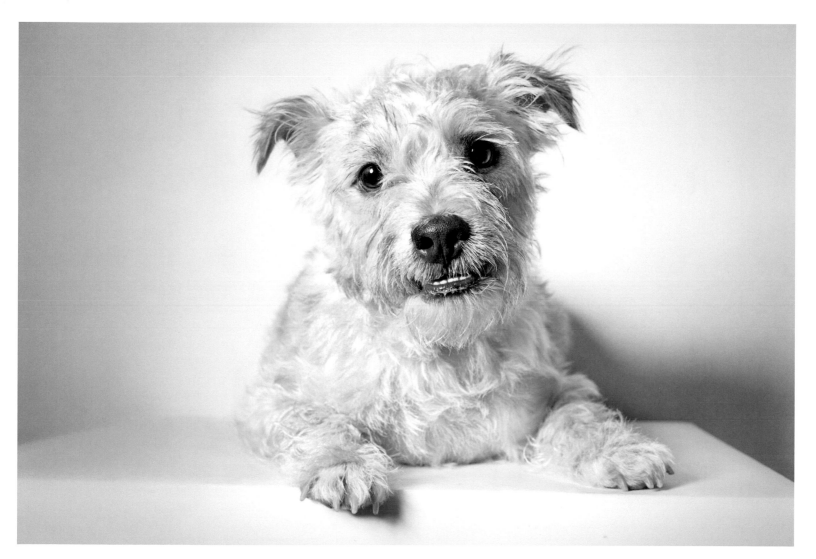

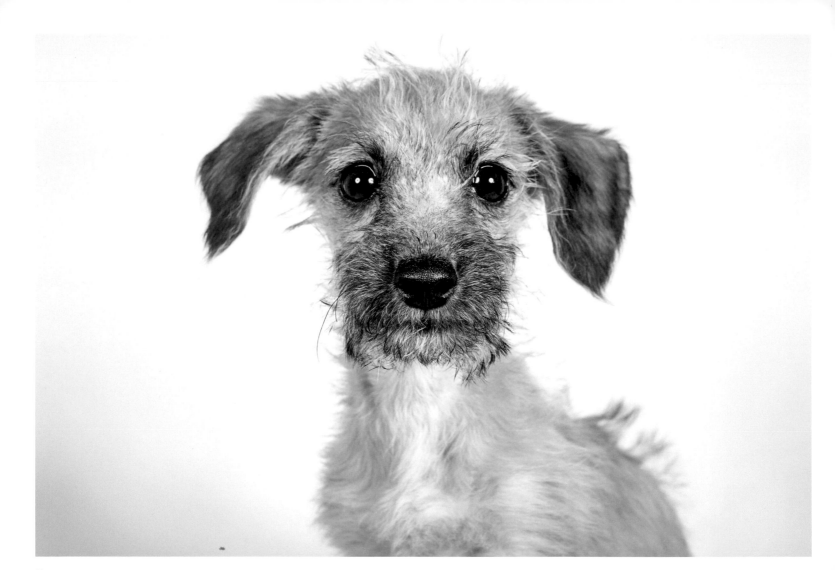

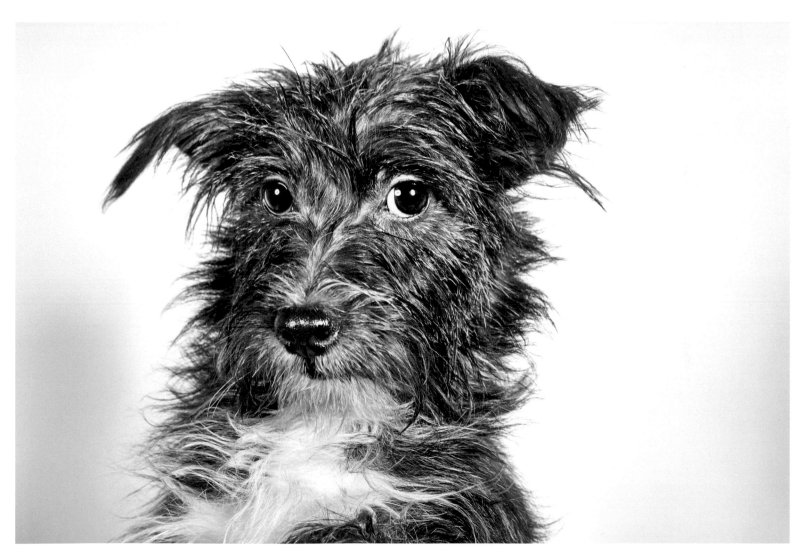

Elmer chelsea

[page 69] Elmer was barely four months old when he was brought to the Humane Society of New York. His owner decided that he had too many dogs and couldn't take care of one more. Shy and quiet at first, Elmer has gained confidence. Now the terrier/dachshund mix loves to play with other small pups at the HSNY adoption center. HSNY is rigorous in matchmaking animals and adopters and building trusting relationships with adopters. "If something is wrong we rely on the adopter to call us, because the animal can't pick up the phone," staff members say. If things don't work out, HSNY will take any animal back. Meanwhile Elmer waits for his adopter. Soon it will be his moment.

[opposite] One down-on-his-luck being reached out to another. When a homeless man found the abandoned dog, he kept her for five days, then realized she needed medical care and a more stable home. Chelsea came to HSNY with unexplained slashes on her head and body. There was no clue about her past life, but she may have been used as a "bait dog," a defenseless chained dog set upon by game dogs as part of a dogfight. After extensive treatment, Chelsea regained her outgoing, playful personality. Jennifer and Adam adopted the Labrador mix just before her third birthday, taking her home to Jersey City and their cane corso named Macy. The two love to play together.

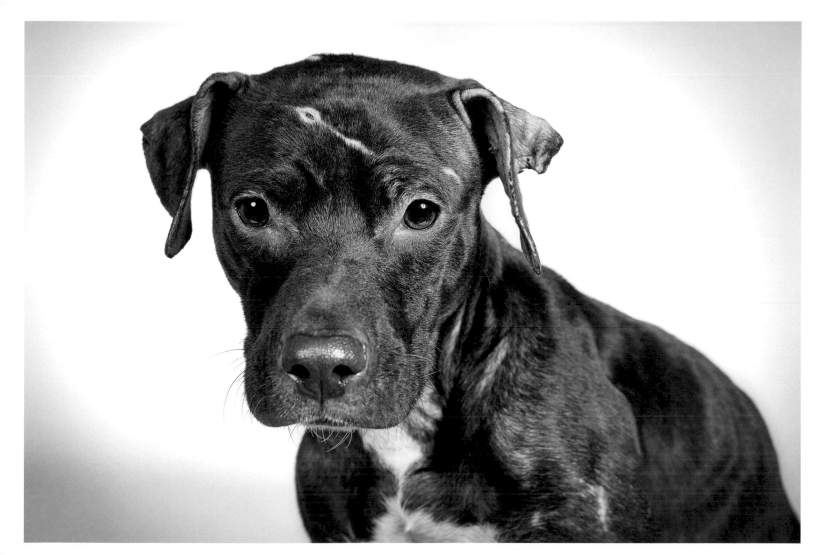

Cosita

Cosita's story is a brutal one. Found tied to a tree in Mexico, surrounded by garbage, sharp metal parts, and her own feces, she had been repeatedly mounted and had given birth to two litters. Then malnourished, with tick-borne diseases and a benign tumor on her reproductive organs, Cosita is now "the happiest dog you'll ever see," says one of the it-takes-a-village-size team of rescuers who negotiated Cosita's release, shepherded her through six weeks of intensive medical rehab, and flew her to her haven at HSNY. "She's a loving and beautiful being who has touched my heart deeply," says the rescuer, pleading for her to be adopted. "I'm sure she'll touch yours."

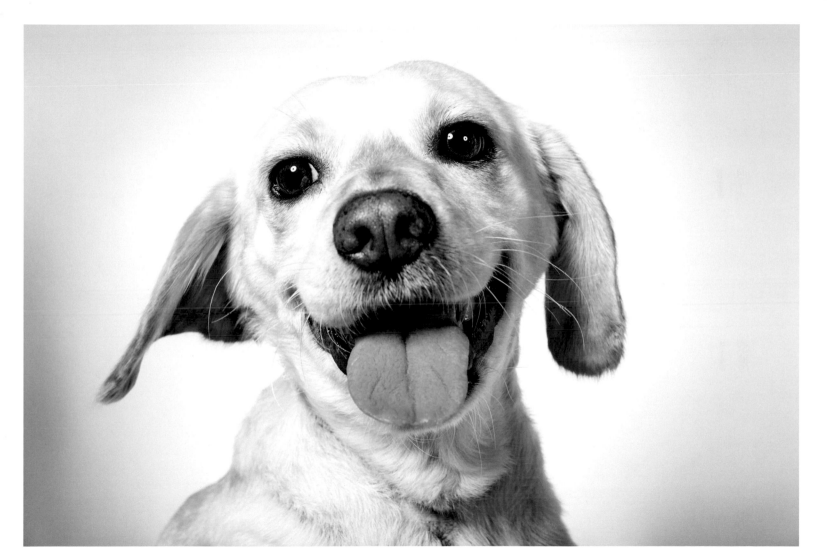

Yoko

Two-year-old Italian greyhound Yoko came to HSNY with two broken legs. Well-intentioned but busy owners hadn't ensured that she was well nourished, leaving her bones brittle. After six months of care Yoko needed a home where her delicate frame would be protected. Luis and Ashley were new to New York and new to having a dog. "Until Yoko, we found it difficult to speak to people. The first day with her we spoke to more people than in the previous six months." Their Upper East Side apartment is ten minutes from Central Park, where Yoko gets a couple of walks each day. Luis works in healthcare IT; artist Ashley takes Yoko along to work, where "Yoko is the studio assistant."

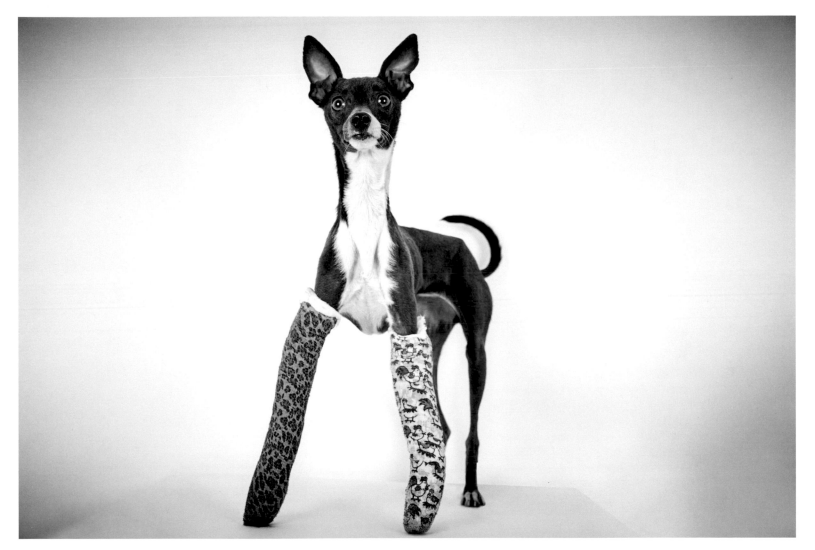

Beauty

Delia

[opposite] An animal lover rescued Beauty and her sister from a kill shelter in the South, paying to have them brought to HSNY, where dogs are safe even if it takes a while to find them a home. Treating the flat-coated retriever/chow chow mixes for heartworm took five months, but finally they were ready for adoption. "She was scared and it took her time to warm up," says Katherine, "but I knew she would flourish in a loving home." Beauty found that home in Katherine's Inwood apartment, and "filled the hole in my heart" left when Katherine's last dog died after fifteen years. "I have a little creature to shower love on all the time."

[page 78] Delia was brought to HSNY by a volunteer who found her at the Humane Society of St. Thomas, Virgin Islands, a kill shelter where Delia was scheduled to be put down if she didn't find a home. Over the years travelers have brought many adoptees—affectionate mixed breeds—from this shelter to HSNY, hoping they'll find happy homes. Delia did, and so the lifesaving St. Thomas–to–New York connection continues. With the irresistible gawky charm of Disney's Bambi, Delia is sweet and demure, quiet, and very loving. She runs like a pony with a smooth, even canter and gets along with everyone.

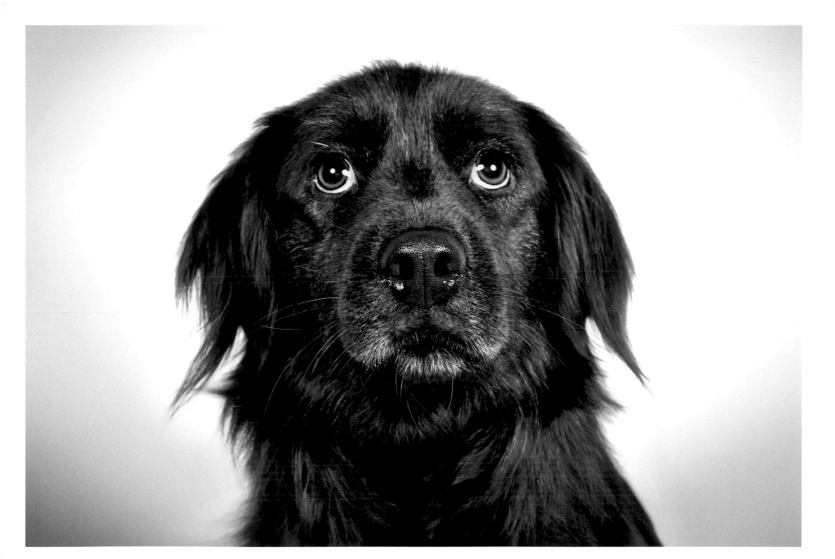

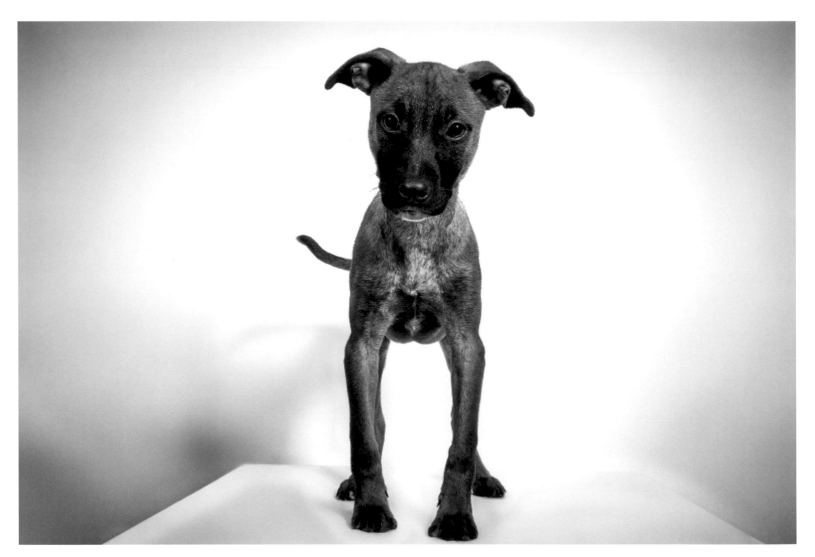

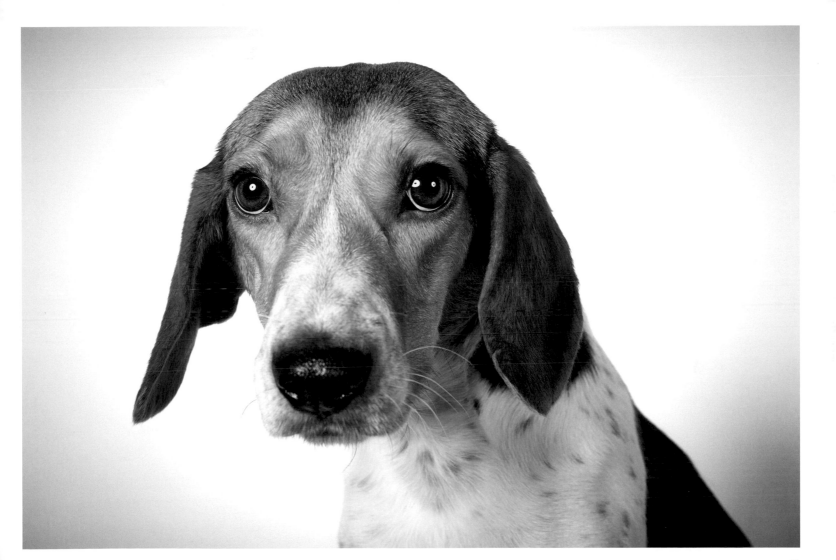

Angelina nico

[page 79] Angelina lies in her bed at the Humane Society of New York, recovering from a serious case of heartworm disease. Her activity is restricted; she must rest completely for at least five months. But though she must stay quiet, her lovely demeanor and empathetic personality have made her a favorite with everyone who meets her. A woman found the three-year-old beagle mix running in traffic. Asking around to locate the owners, she was told by a doorman that he'd seen a couple arguing; after dropping the dog's leash, they simply walked away. No one ever came looking for Angelina. At HSNY the four-year-old received complete medical care. Soon she'll be healthy enough for a new home and a new beginning.

[opposite] Like many dogs bought from pet stores, Nico paid the penalty for an owner's rash purchase decision. Not long after a young woman bought the cairn terrier, she decided she could not afford his care. When Nico came to the Humane Society of New York he had lost much of his hair, an allergic reaction to flea bites (his owner hadn't used flea protection). Soon Nico, his inflamed skin soothed by medications and baths, was feeling better. Now fully healthy again, the one-and-a-half-year-old loves to run, play fetch, and then run some more. A shrewd observer of life, he notices everything that's going on around him. Now all he needs is a stable owner and a permanent home.

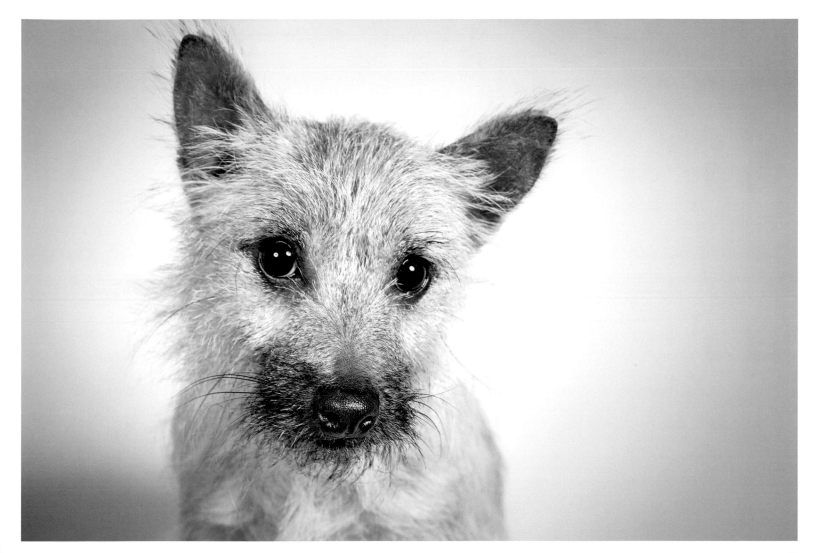

maggie + bailey

Maggie and Bailey came to HSNY at just five weeks old with their mother, Miracle, who nursed the puppies until they were old enough to be weaned. The sisters—brown Bailey is the "sweet" one; white Maggie is "a little more crafty"—went to one home; their mother, who didn't like other dogs, to another. At three months old the sisters were featured on Mary's station's morning show, but Mary, a TV news producer, missed the segment. "I'm lucky somebody didn't snatch them up!" Since the adoption, Mary's family has moved from an apartment to an Edgewater, New Jersey, house with a fenced-in yard. The dogs "adore each other and often sit in the same pose," as in their photo.

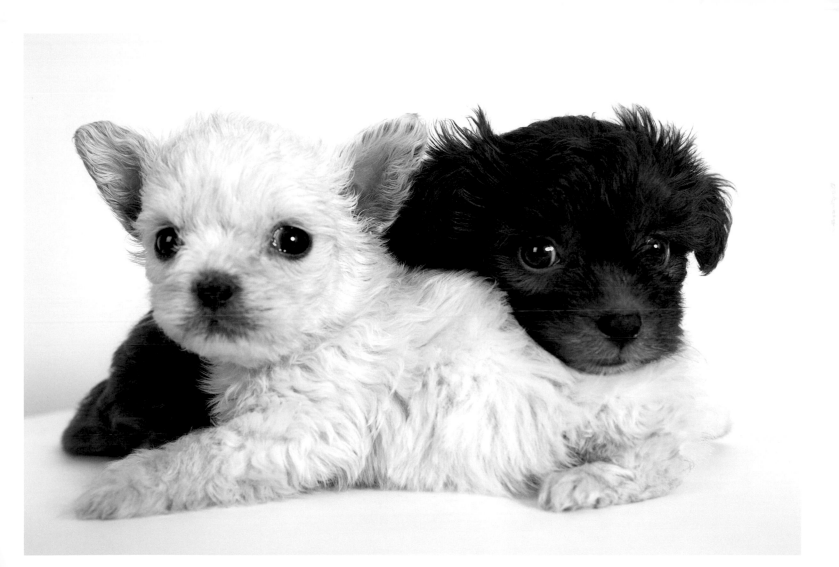

Terry Kaitlyn

[opposite] Terry's owner, aging and sick, fed him unhealthy take-out food and rarely took him outside. When she died, Terry came to HSNY. "It took a while for Terry to relax," a staffer says. He's still a little shy, according to adopters Derek and Lillian, who run a small jewelry business. "We wish he was more confident, but he doesn't have to worry with us." Derek and Lillian had just turned out the light one night when they felt an enormous thump. The newly adopted Terry had jumped up onto their bed to nestle between them. Terry made just as close a bond with the couple's other dog, Monkey, who until then had been mourning the loss of their previous pet.

[page 86] Kaitlyn's background is a mystery up to the moment she was found by a woman doing TNR (trap, neuter, return) work with colonies of cats. Obviously starving, the five-year-old dachshund/beagle mix jumped into the woman's car and wouldn't leave. In time, Kaitlyn was brought to HSNY. Now she shares a Long Island City house and big yard with "two loving daddies." Tony runs an air-conditioning company; Ward is an aspiring actor and model. Kaitlyn joined the ménage a month after Ward's mother died unexpectedly, and the dog "has been an emotional support during this rough time," Tony says. "She's a little bed hog, so we traded in our California king for a wider eastern king to accommodate the princess."

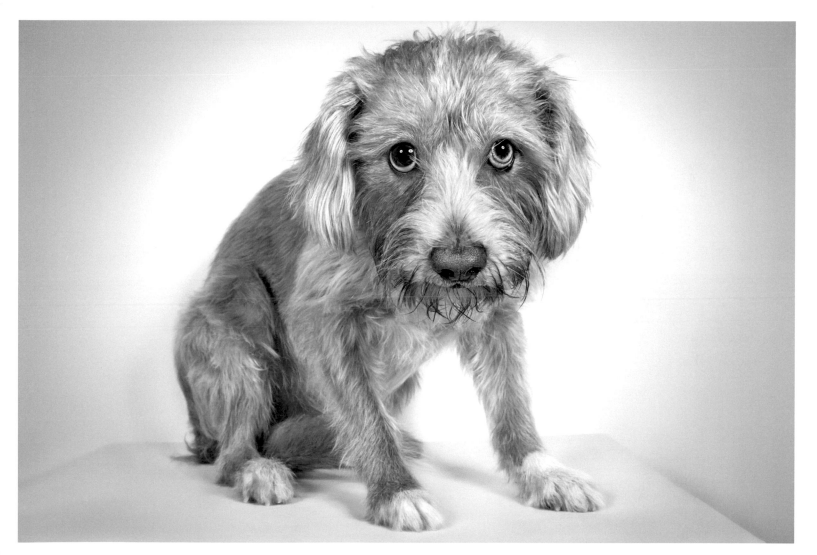

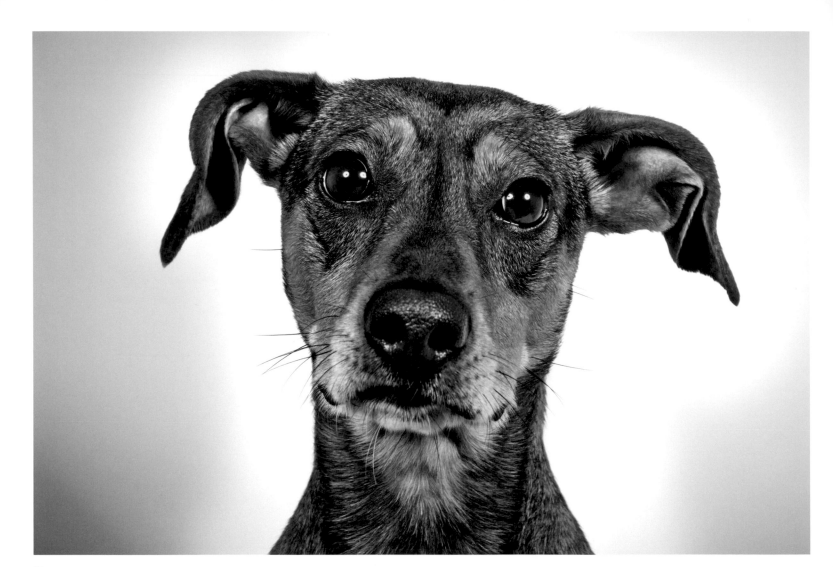

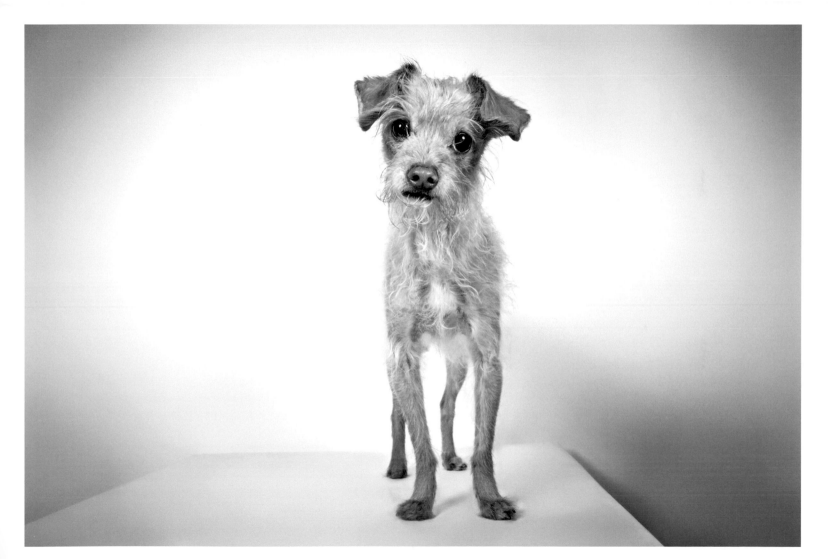

bruce

regina

[page 87] Bruce, a ten-year-old stray left in a Long Island kill shelter, had such bad teeth that one fell out as he was moved to HSNY. Only after extensive care, including the extraction of fourteen more teeth, was he ready for adoption. Bruce caught Eliza's eye from the start. "He was older, had bad eyesight, and was skinny. That melted my heart!" Bruce joined the family's three other "adopted terrier types"—Eliza says her family consists of three boys and three dogs—and all merged into "one big pack of scruffiness." Soon "Bruce would race around our apartment as if he were running for joy, knowing he was in a loving household." Four months later Bruce died, secure in that knowledge.

[opposite] Just seven months old, Regina became yet one more puppy given up by an owner who wasn't prepared to take care of her. Two months later she had better luck. "Regina was so inquisitive and friendly," remembers Melissa, a teacher who lives with her children, ages five and six, in a house in Newark, New Jersey. "I knew she'd be a perfect addition to my family. Now I no longer have to pull teeth to get the kids up: Regina wakes them every morning. Both kids 'work' to have special privileges, like who will help Mommy bathe Regina or whose bed she'll sleep in. Since we adopted Regina, there's definitely more laughter in my house."

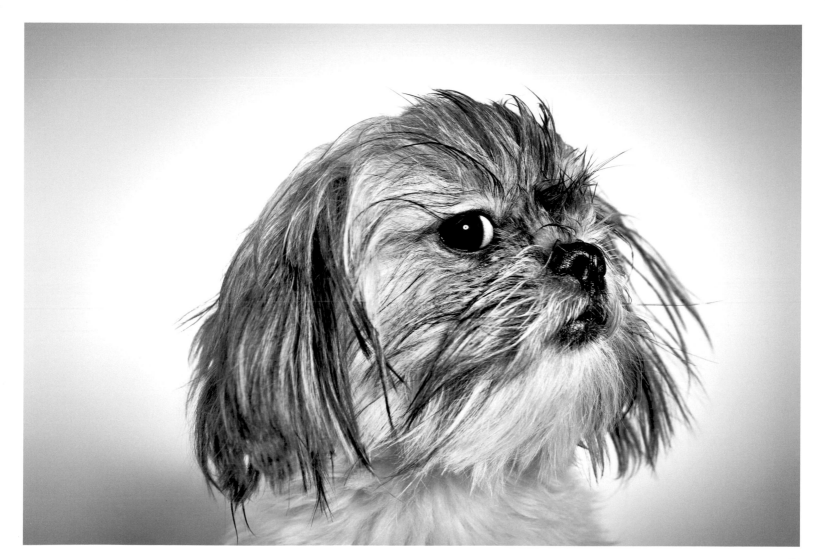

Cedric

Sold as a hypoallergenic breed, Cedric, a five-month-old cockapoo, ended up at the Humane Society of New York when the family that bought him found themselves highly allergic to their new dog. For Christopher and Andres, he was the perfect "little brother" they'd been looking for for Chloe, another cockapoo, age six. Home is a high-rise in Hell's Kitchen—with a second place in Miami—and the pier, park, and runs on the West Side Highway keep everyone fit. "Each day Cedric comes a little more out of his shell and gains confidence," Christopher says. Christopher works in architecture and interior design. Cedric and Chloe "are my two assistants, and both have a good eye for color."

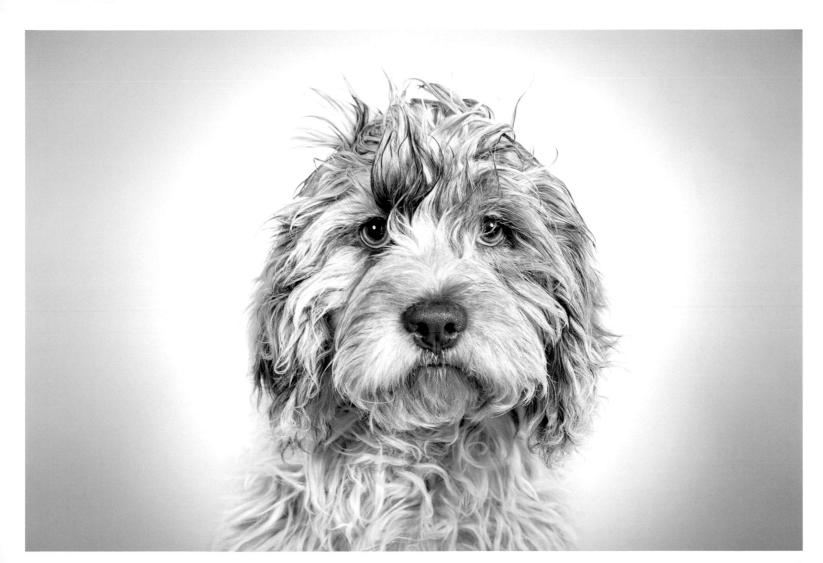

Bella

The call came in from a Long Island kill shelter: Bella was about to be euthanized; could HSNY help? Bella has the ice-blue eyes of a husky and the high-set ears of a Labrador retriever. For nine months she's lived with Kim and Greg, who take Bella for long walks in the glens and gullies surrounding their house in suburban Rochester, New York. "Having just retired, it's been an adjustment to have less social interaction during the day," Kim says. "Taking Bella to the dog park allows both of us to make new friends." Like many rescues, Bella had separation anxiety when she arrived, but it's fading, and she no longer scratches at the back door when the couple goes out.

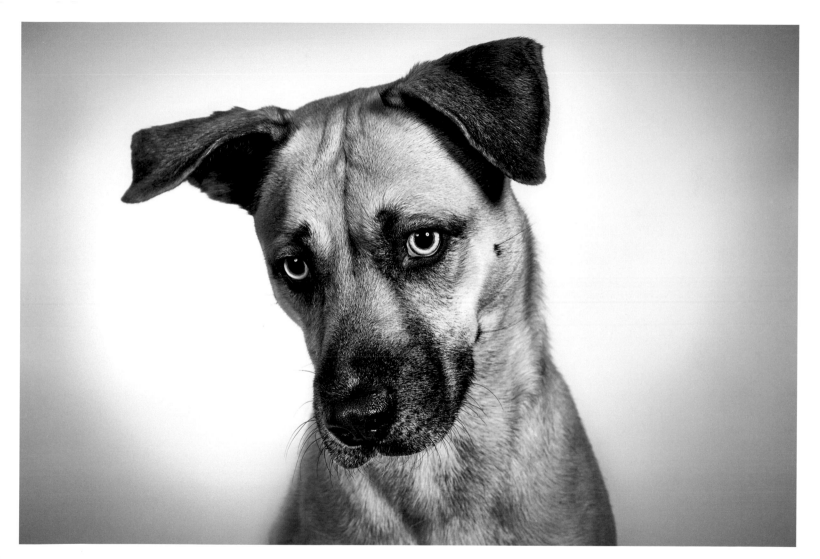

chico

An abuse survivor, Chico arrived at HSNY with a badly broken front leg. Humane Society veterinarian Lizzie Higgins was charged with his care. A veterinary orthopedic specialist plated the fracture; once healed, Chico was ready for adoption. Lizzie had been considering taking on another dog but was envisioning an Irish setter type until "I realized how special this little guy is. Incredibly sweet, gentle, and calm." Two years ago Chico joined Lizzie's family—he adores her partner, their kids, and the two other dogs, although "he could take or leave the cats. He's definitely not the running partner I was looking for," Lizzie says, "but he's the best snuggler and listener."

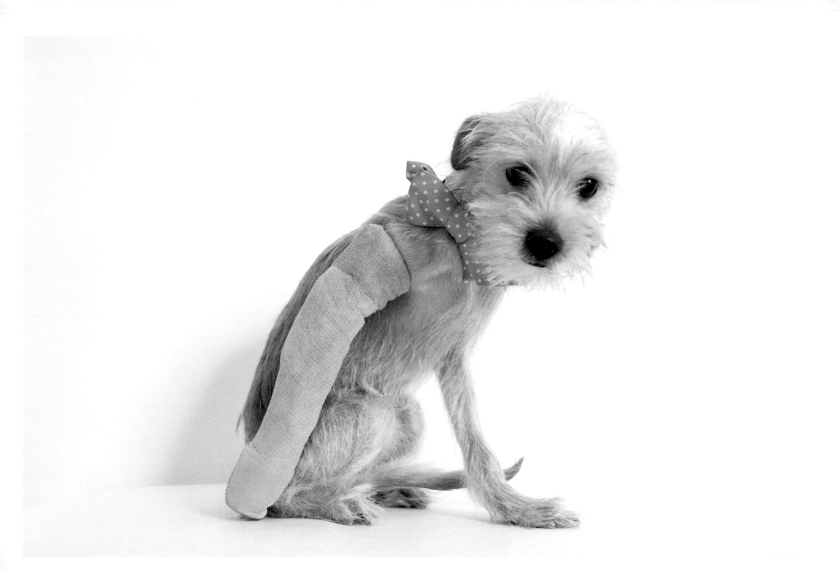

stanley Hamilton

[opposite] Stanley was wet, rail-thin, and hungry when a woman found him shivering inside an upended trash can. He had no identification. She asked several shelters to take Stanley; HSNY said yes. Deaf, with his eyes so infected he could barely keep them open, Stanley may have been a "throwaway dog," discarded by a former owner. HSNY doctors estimated his age to be twelve. After intensive care, Stanley got his second chance. "We had counted the days until our retirement so we could have time for a dog," says Lisa. She and husband Tom live on the Jersey Shore; Stanley loves to explore their fenced backyard. "Despite the hardships he's known," Lisa says, "Stanley is a happy-go-lucky fellow with a zest for life!"

[page 98] Friendly, outgoing Papi, a two-year-old Chihuahua mix, was rescued from a Texas kill shelter just before his time ran out. A new home with Caroline and a name change, after her favorite founding father, made all the difference. An NYU student majoring in history and photography and an intern at *Saturday Night Live*, Caroline lives with Hamilton and her other adopted dog in an East Village apartment. A dog park is nearby. "He's my best friend," she says, "my comic relief, my pup in shining armor, my real-life Alexander Hamilton."

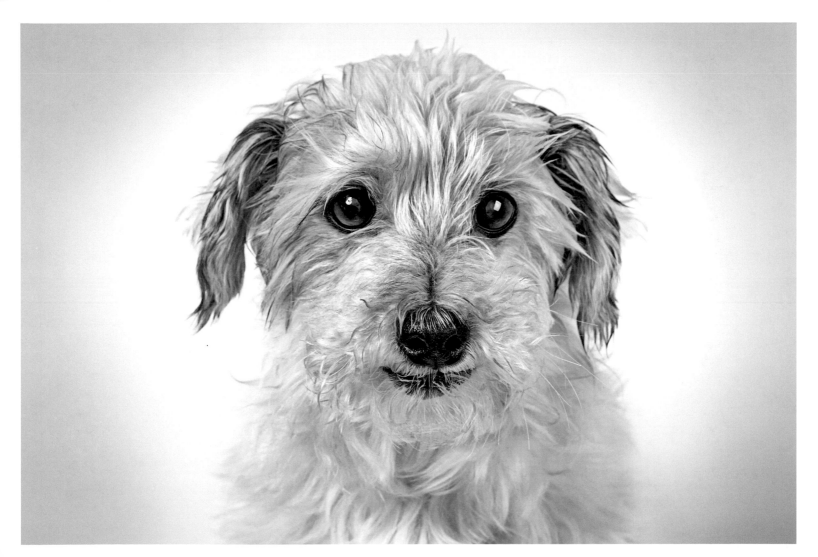

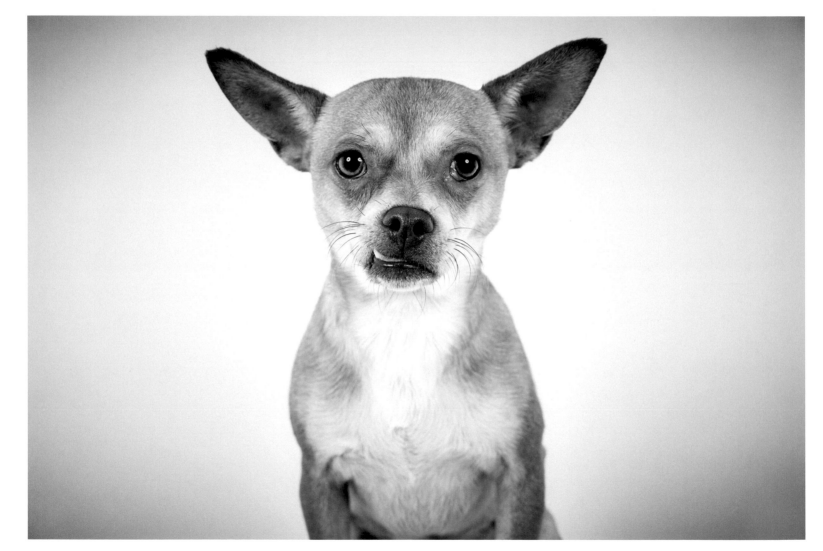

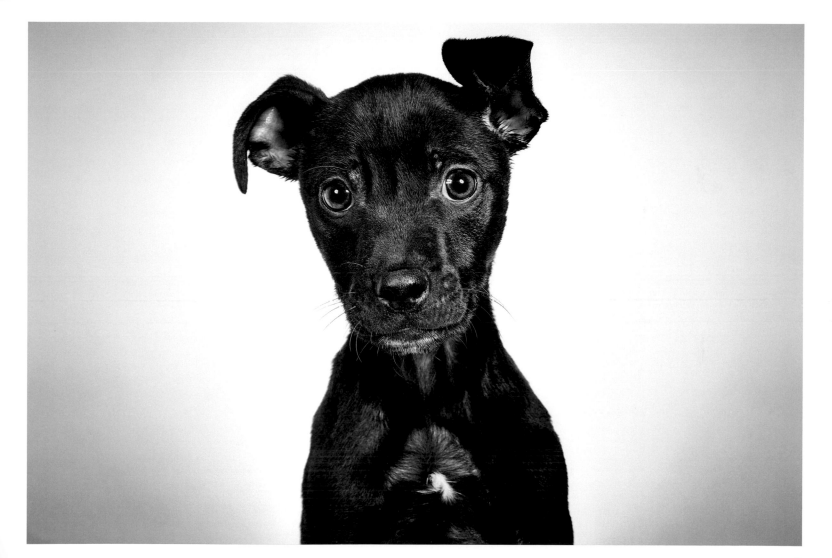

hugo

lucas

[page 99] Hugo is another survivor of the Caribbean kill shelter that asked HSNY to find homes for several dogs, including this terrier mix. Like many adopters, Tom and James felt an instant connection when they met Hugo; soon they set up an Instagram account to chronicle the "devilishly handsome" pup. Their days require more careful scheduling now, the partners say, to make sure growing Hugo gets the walks he needs. But if there are "less spontaneous happy hours or long evenings out," they have found a new social circle of "dog people," which meets for playdates at their Hell's Kitchen apartment and for long group walks.

[opposite] Lucas wasn't the first dog to lose his place when a newcomer arrived on the scene. The owner of this poodle/terrier mix was having a baby and couldn't manage to care for Lucas too. The Humane Society of New York staff found him sweet, loving, and playful, a "dream" for someone who had time to complete his puppy training. Andrey was just the one. He and his two roommates are "crazy in love with Lucas," who is now a year and a half old, housebroken, and completely at home in his trendy Brooklyn neighborhood.

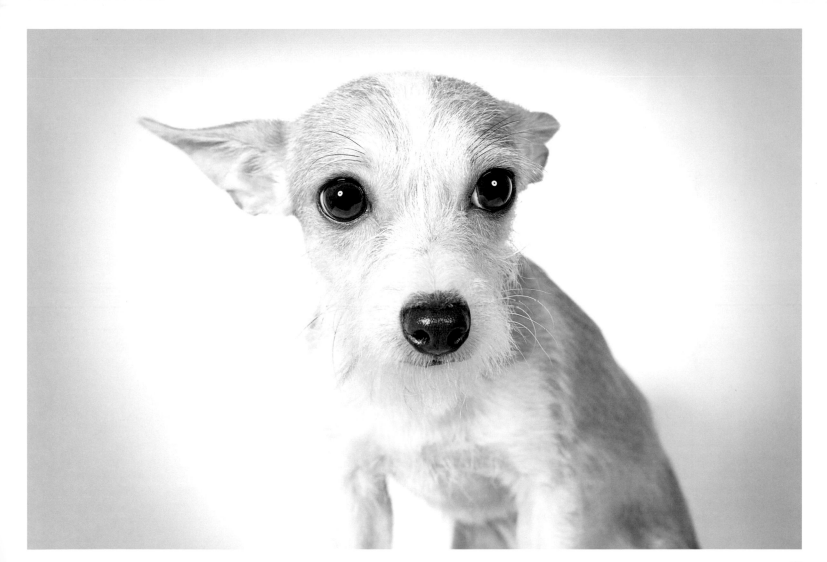

maya

timmy

[opposite] Too ill to feed or walk a dog regularly, Maya's owner surrendered the three-year-old to HSNY. When Lori heard about the Boston terrier who snored, it seemed like a sign: the family pug, who'd died months before, had snored too. When Lori's family met Maya, "she melted in my son Frank's arms," Lori says. One can-you-believe-it moment: "Maya's little bed was on the sofa. She took it in her mouth, jumped down, and carried it over to the sliding door to place it in the sun." Husband James has a construction business, but with serious illnesses, "I'm home most of the time," Lori says. "Maya's hardly ever alone, which is good for her—and me. Maya is like a therapy."

[page 104] Almost two and painfully shy, Timmy was another refugee who came to HSNY from a Texas kill shelter. It took time to build up the confidence of this Chihuahua mix, who clearly loved other small dogs, HSNY staffers say. Erich and W. T. decided Timmy was the perfect match for them—and for Puck, their fourteen-year-old miniature pinscher. The four live in the first floor of a house in Astoria. Timmy gets lots of walks, but even after coming home he has energy left over to run laps around the apartment at breakneck speed. Adopted four months after the death of another much-loved "min pin," Timmy "fit right in," Erich says. And his photo? "That's Timmy through and through."

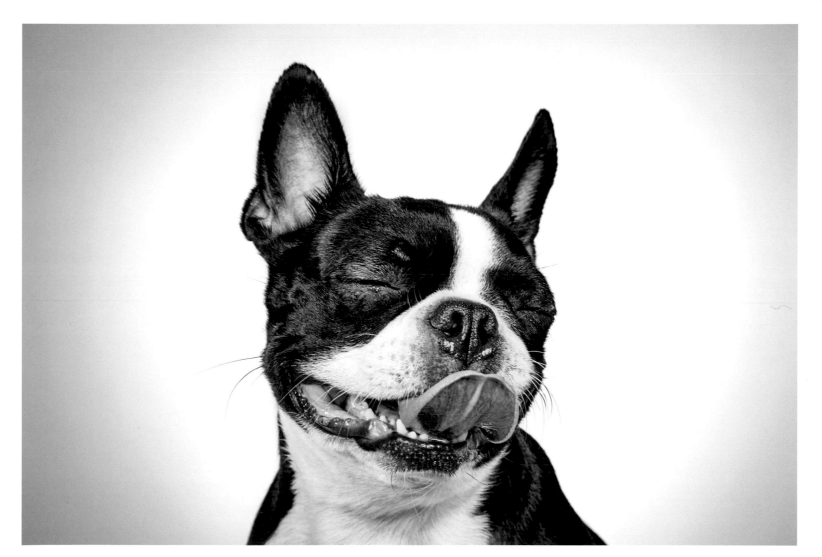

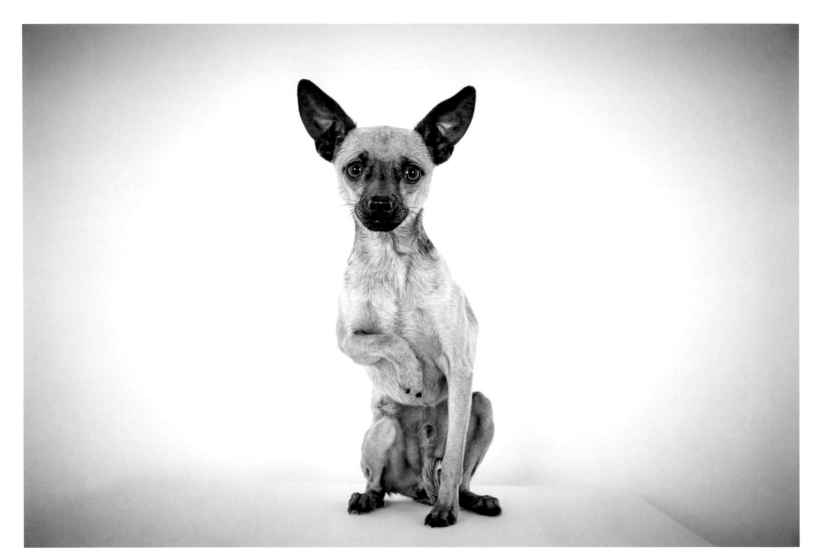

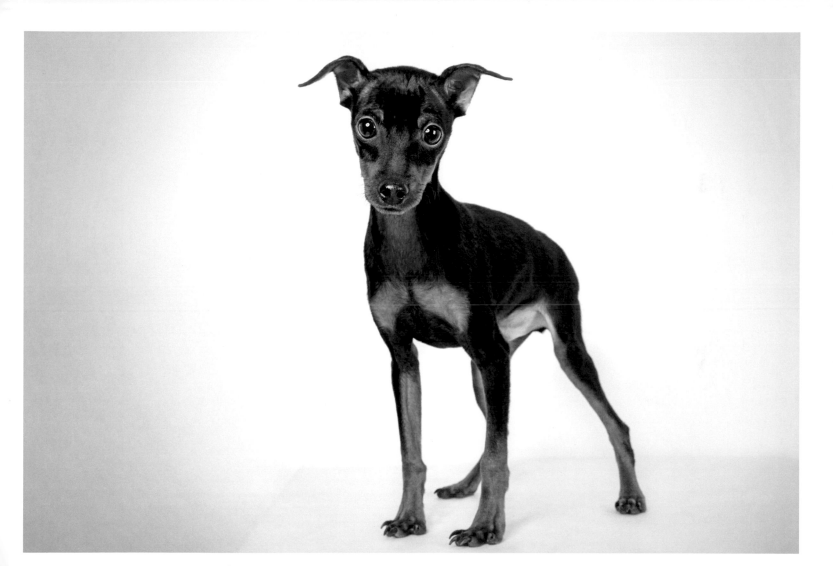

halston timothy

[page 105] Soon after buying this puppy from a pet store, the young owner lost her job and was evicted. She asked HSNY to find him a lasting home. After vaccination, deworming, and neutering, the miniature pinscher reinvented himself, starting a new life as a fashion insider. When Terry took the dog home in a taxi, "he stood so poised on my lap, I knew he needed a sophisticated new name to go with his style." Terry, a fashion director, shares a Flatiron loft with his partner, an anesthesiologist, who has his own relationship with the renamed Halston. "He's our baby," says Terry, but "I work in fashion and I make sure Halston's fashion is just as important as mine!"

[opposite] The owner said he and his family were moving and couldn't take Timothy and his brother Kirby (see page 27) along, so he surrendered the five-year-old dachshund/Chihuahua mixes to the Humane Society of New York. Timothy must have been overwhelmed at being left behind; he had a seizure about an hour later. Now, friskier and more outgoing than his brother Kirby, who has been adopted, Timothy loves to cavort with other dogs on the HSNY rooftop dog run. He hasn't had any more seizures and he's aced all his medical tests—he's ready to be adopted. Now he's just waiting for a best friend.

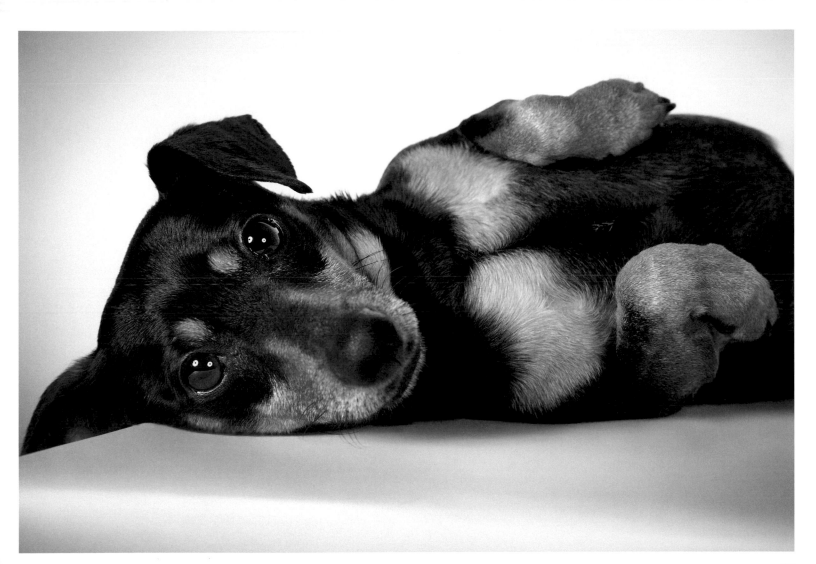

toby Tobias III + Lafayette

Banished to a New York kill shelter upon the death of his owner, Toby Tobias III lived at HSNY for ten years after his rescue, appearing at adoption events and on TV shows. Only later did he find the right home himself—in San Diego, with Julia, production coordinator for a fashion company, and Paul, a financial underwriter. "Toby showed us that senior dogs are incredible!" Julia says. Since Toby had a hard time jumping up on their bed, the couple got him a set of stairs. "You can teach an old dog new tricks." Lafayette, pictured with Toby, was another HSNY staff favorite. He died young but, a staffer recalls, "gave us so much joy while he was here!"

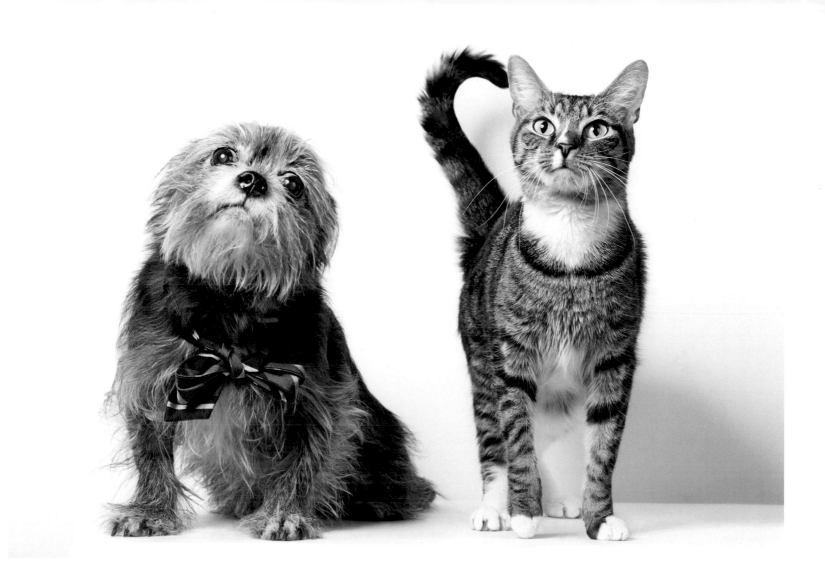

Humane Society of New York

Since 1904, the Humane Society of New York has been a presence in New York City caring for animals in need when illness, injury, or homelessness strikes. Originally founded to protect the city's working horses against abuse, the Society fought for laws to punish negligent owners and placed watering troughs in streets and parks. As funds allowed, the Society opened a free medical clinic and a small adoption center for cats and dogs. Today, their hospital and their Vladimir Horowitz & Wanda Toscanini Horowitz Adoption Center help more than thirty-eight thousand animals annually, and the numbers continue to grow.

At the Society, the quality of each life is paramount. Long before it was popular to think of animals as individuals—to consider their physical and emotional needs when taking responsibility for their care—the Society was doing just that. That means every day, every dog receives training and exercise time in the rooftop run, and the chance to walk outdoors with staff and volunteers. Cats enjoy daily play sessions outside their kennels. This very personal care is fully as important to a pet's well-being as the inoculations, spay/neuter procedures, and other veterinary care provided during its stay in the adoption center.

For many of New York's most disadvantaged residents, the Humane Society of New York's hospital is the only place they will find help. Programs include a full-service, low-cost hospital, open seven days a week, offering comprehensive, affordable medical care. The Society underwrites millions of dollars of critical care annually, along with our Animal Emergency Appeal, Animal Mukti Free Spay/Neuter Program, and other services.

HSNY's Vladimir Horowitz & Wanda Toscanini Horowitz Adoption Center is a unique shelter where homeless animals live and thrive until they are placed in loving, responsible homes. In addition to being given any medical care that they might need, all adoption animals are spayed or neutered, vaccinated, and microchipped. Along with providing physical necessities, the Society also meets the animals' emotional needs. All of the dogs up for adoption are evaluated and put on training programs by our director of animal behavior. "This doesn't feel like a shelter," remark many visitors to the Society. "It feels like a home."

Of the millions of charities across the United States, fewer than two thousand have been awarded the Independent Charities of America Seal of Excellence. The Humane Society of New York is one of these.

Richard Phibbs

has shot campaigns for Giorgio Armani, Ralph Lauren, and Calvin Klein, and his work has appeared in *Vanity Fair*, *Vogue China*, *Harper's Bazaar Spain*, and *Paper*. Phibbs's art photography is in the collections of Francis Ford Coppola, Ralph Lauren, and Michael Eisner. The best of his portraits and fashion photographs from over a decade are featured in his first book, *Chasing Beauty* (2010). Most recently he published his view of the North American West in *The West* (2015). Phibbs is an advisory board member of the Humane Society of New York, which awarded him the HSNY's Humane Medal in 2015. Born and raised in western Canada, Phibbs has degrees from the University of Toronto and Parsons School of Design. He lives in New York City with his own rescued buddy, Finn (see page 39).

Richard Jonas

was trained as a journalist and has worked as a reporter, editor, and film and pop music critic before focusing on writing TV commercial scripts for leading national brands. An activist and teacher, Jonas also writes extensively about yoga.

James Victore

is an artist, speaker, author, and illustrator who runs his own independent design studio. His work is in the collection of the Museum of Modern Art, New York, and he is the author of *Victore or, Who Died and Made You Boss?* (2010).

Thanks to Andy Dean, Cary Bower, Christopher Ewers, Emily Sauer, Georgia Nerheim, Ira Morris, Joe Toto, Jordan Shipenberg, Melody Brynner, Mike Dos Santos, Patrick Klinc, Patrick Stroub, Tre Cassetta, and Versatile Studios.

Special thanks to Virginia Chipurnoi, Sandra DeFeo, and the dedicated staff at the Humane Society of New York for doing God's work every day!

Thanks to Teddy Borsen and Chika Kobari for their support and dedication.

Thanks to Ken Kobayashi and TREC and Shawn Hallinan and Duggal Visual Solutions for their generosity and support.

And thanks to Instagram for creating a revolution by bringing the message about adopting shelter animals to a global audience.

Richard Phibbs

Rescue Me
Photographs by Richard Phibbs
Text by Richard Jonas
Typography by James Victore

Editor: Chris Boot
Project Editor: Nicole Maturo
Imaging: Chika Kobari
Creative Supervisor: Teddy Borsen
Designer: Brian Berding
Production Director: Nicole Moulaison
Senior Text Editor: Susan Ciccotti
Proofreader/Copy Editor: Sally Knapp
Work Scholars: Minchai Lee, Melissa Welikson

With special thanks to the Louise and Leonard Riggio Foundation for their generous support.

First edition, 2016
Printed by Midas in China
10 9 8 7 6 5 4 3 2 1

Library of Congress Control Number: 2016905661
ISBN 978-1-59711-338-0

To order Aperture books, contact:
+1 212.946.7154
orders@aperture.org

For information about Aperture trade distribution worldwide, visit:
www.aperture.org/distribution

aperture

Aperture Foundation
547 West 27th Street, 4th Floor
New York, N.Y. 10001
www.aperture.org

Aperture, a not-for-profit foundation, connects the photo community and its audiences with the most inspiring work, the sharpest ideas, and with each other—in print, in person, and online.